S0-AGF-376

FRED DALKEY: RETROSPECTIVE

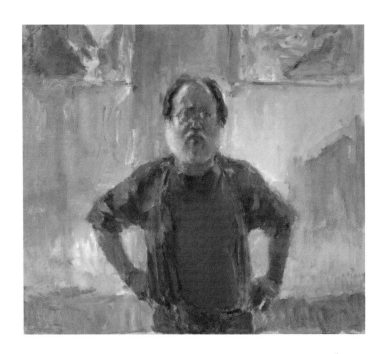

Essays by

Peter J. Flagg

Wayne Thiebaud

Chris Daubert

Julia Couzens

Michaele LeCompte

Richard Wollheim

CROCKER ART MUSEUM

March 9 - May 12, 2002

LENDERS

In addition to the artist, the following have loaned artwork to this exhibition:

Reza Abbaszadeh

Clyde Blackmon and Karen Cornell

Ada Brotman

Barbara Bumgarner and Frank Teribile

Barbara Zook Caine

Charles and Glenna Campbell

Frank Caulfield

Herbert Harris Danis and Rose Vern Danis

Tony and Eli DeCristoforo

Larry Evans Fine Art

Morgan Flagg

Penny Harding and Bill Mahan

Mike Heller, Sr.

Scott and Laura Hill

Richard Hille

Kathryn Hohlwein

Marilyn and Phil Isenberg

Kronick, Moskovitz, Tiedemann, and Girard

Frank LaPena

Kendall and Michaele LeCompte

Bill Mandelstam

Betty D. Mast Collection,
Courtesy of the Melville Family

David and Karen Mast

Anne and Malcolm McHenry

Burnett and Mimi Miller

Carl and Ann Nielsen

Karen E. Onstad-Corriveau

Bill and Sue Parker

Mr. and Mrs. Harry Parker III

Elizabeth and Mason Phelps

Carol Ross

Steven and Nancy Schwab

Karen Searson

Russ Solomon and Elizabeth Galindo

Jeffrey and Ann Taylor

Paul LeBaron Thiebaud

Betty Jean Thiebaud

Gregory and Andrea Trautman

Wendy Turner

Mr. and Mrs. James V. de la Vergne

Jian and Bonnie Wang

Susan and Thomas Willoughby

Several Private Collections

© 2002 Crocker Art Museum
 © 1997 Richard Wollheim for "The Drawings of Fredric Dalkey"
ISBN 0-9674288-1-5 (hard cover)
ISBN 0-9674288-0-7 (soft cover)
Library of Congress Catalogue Card Number 2001099912

Catalogue designed by Rakela Company, Sacramento
Printed by Color-IV Press

Cover and Title Page:
Self-Portrait with Hands on Hips, 2001
oil on linen
28" x 32"
Collection of Fred and Victoria Dalkey

DONORS

Crocker Art Museum would like to express appreciation to the following individuals and businesses whose contributions have made this catalogue possible:

Creative Arts League of Sacramento
in memory of Kathryn Uhl Ball

Phil and Marilyn Isenberg

Malcolm and Anne McHenry

Paul LeBaron Thiebaud

Susan and Thomas Willoughby

Roger and Carol Berry
Kirk G. Bone
California Cable Television
 Association
Julia Couzens and Jay-Allen Eisen
Starr and Ed Hurley
McCuen Properties
Burnett and Mimi Miller
Plumbers & Pipefitters Local Union
 No. 447
Ronald G. Pomares and
 Marilyn C. Mahoney
River West Investments
Byron and Linda Sher
Kathleen Snodgrass
Solomon Dubnick Gallery
Townsend, Raimundo, Besler
 & Usher
Diana K. Young

Hilary Abramson and Tom Rosenberg
Bruce Beck
Linda A. Bell
Birdie Boyles
Stephen and Susan Bradford
Doris Brown
Barbara Bumgarner and
 Frank Teribile
Gloria and Walter L. Burt III
Phillip Caine
Mike and Katy Cardwell
La Vonne and Dan Chase
Sally and Ed Clifford
Phil and Ruth Coelho
Victor Comerchero
Duncan M. Courvoisier
Patricia D'Alessandro
Rose Vern Danis and
 Herbert Harris Danis
Tony and Eli DeCristoforo
Bill and Carol Dillinger
Jerome and Betty Dobak

Patrick Dullanty
Quinton and Nancy Duval
Robert Else and Jorjana Holden
Jerry and Clyde Enroth
Peggy and Emanuel Epstein
Anita and Larry Fein
Alice Fong
Marjorie J. Francisco
Joseph and Harriet Freitas
Emanuel Gale and Mary Zeppa
Robin Leddy Giustina
Dianne Gregory and Nancy Gotthart
John and Helen Hansen
Penny Harding and Bill Mahan
Rodger, Betsy and Margaret Hille
Maru and Tom Hoeber
Kathryn Hohlwein
Alfred E.and Ruth A. Holland
Lois Hunt
JayJay
Muriel and Ernie Johnson
Pam Hunter Johnson and
 Andrea L. Spark
Arvilla T. Jones
Wolf Kahn
Peter Keat and Miriam Davis
Bob, Bette and Judi Keen
Daniel and Louise Kingman
Kay and Gene Knepprath
Gregory and Moni Kondos
A.J. Krisik
KD and Gary Kurutz
Laureen Landau
Cathy Landgraf
John and Ann Landgraf
Robert and Averil Leach
T. Leaver
Leon Lefson
Kay Lehr
Susan Lyon and Sarah Phelan
Pat Mahony and Randy Getz
Bill Mandelstam
Garth and Linda Martin
Karen and David Mast
Lee and Cheryl McDonald
Patricia Tool McHugh
Dale and Pamela Melville
Annie Menebroker
Tom Minder
Mary Anne Moore and
 Maurice Read
Francine Moskovitz
Tony and Donna Natsoulas

Carolyn Negrete
Doris Niccolai
Karen Onstad-Corriveau
Michiyo Osuga
Jim and Terry Pappas
Steve and Margie Parada
Michael and Jill Pease
Miles and Barbara Pepper
Nina and Dick Planteen
Annette Porini
Helen and Alan Post
Robert H. Putnam
Simone and Mark Rathe
Joan Read
Chris Reding and Randall Fleming
Ruth Rippon
Jean Roach
Estelle Saltzman
Theo and George Samuels
Eileen and Howard Sarasohn
Bill and Julia Schaw
Rochelle and Michael Schermer
Dennis and Loretta Schmitz
Carolyn Schneider and Bill Yates
Mike and Priscilla Sellick
Isabel Shaskan
Brent M. Smith and
 Paul E. Wortman
Jean Stephens
Michael Stevens and Suzanne Adan
Hulda Stone
Emily and Melvin Stover
Marguerite Sullivan
Gilda Taffet and Doug Pauly
Wade A. Tambara D.M.D
Henry & Wendy Teichert
Michael Tompkins and
 Grace Munakata
Tower Framing
Robert J. Tzakiri and Gary L. Watkins
Judge Brian R. Van Camp and
 Diane D. Miller
Eleanor Van Valkenburgh
Jian Wang
David and Lois Warren
Bette and Ken Waterstreet
John Weber
Judith and Malcolm Weintraub
Diane White
Winfield Gallery, Carmel
Leilani Yang
Anonymous

THE ART OF FRED DALKEY

LIAL A. JONES, DIRECTOR
CROCKER ART MUSEUM

Fred Dalkey's art ranges from figurative to abstract, hard-edged to undefined, and miniature to monumental. A diverse artist capable of both great sensitivity and shocking honesty, there are, all the while, consistent qualities that run through his work that are identifiably his own. Luminous light, eternal stillness, pensive moments, and poignant introspection are Dalkey's signature elements. Distinctly local in inspiration, Dalkey's art transcends locale to become broadly meditative, seeking the universal through the specific.

A native Sacramentan, Dalkey grew up and studied here. His art concerns the local landscape and people, the subjects he knows intimately. Dalkey's landscapes in particular continue a long tradition of depicting the natural glories of the Golden State. Akin to California Luminists in the Crocker Art Museum's collection – William Marple (1827-1910), Gideon Jacques Denny (1830-1886), and William Keith (1838-1911) for instance – Dalkey portrays California's light and atmosphere with a palpable reverence. A transcendental quality of divinity in nature and a sense of wonder in the beauties of the natural world are manifest in his work. Unlike most early California artists, however, Dalkey does not avoid the encroachments of modern life – telephone poles, paved roads, and buildings – but seemingly embraces them, often

bathing them in the forgiving glow of twilight. Even when depicting only nature, such as in his many paintings of urban parks, it should be remembered that this too is a domesticated wilderness, and a conspicuously modern creation.

To be sure, there is no mistaking Dalkey's paintings as anything but contemporary. Elements of our modern-day world are distinctly present, and Dalkey applies paint in a forthright and unapologetic manner that is undeniably of our time. Paint is applied with even greater abandon in his figurative works, capturing the essence of the human form through an economy of means. Over the course of his career, Dalkey's approach to the figure has become increasingly about this form and less about his subject's physiognomy or personality. As in his landscapes, light takes center stage; the figure itself becomes secondary – a mere shape that light defines. Light is also used to dramatic effect in his sensitive Conté crayon drawings. Although these drawings are primarily figurative, Dalkey also shows us that other objects, even those as mundane as a ball of string, can assume a poetic and haunting beauty.

It is the goal of this exhibition to recognize Fred Dalkey as one of Sacramento's premier artists and to present the breadth of his production. Surveying thirty years of work, the exhibition includes

4

portraits and self-portraits, urban landscapes and park scenes, figurative work, and drawings.

Many Dalkey supporters have contributed to assembling this material, particularly the exhibition team: Victoria Dalkey, Chris Daubert, and project coordinator Susan Willoughby. Peter J. Flagg and Scott A. Shields provided curatorial oversight to the project.

We are most grateful to Fred Dalkey for his enthusiasm in allowing us to present his work. Not only does this exhibition celebrate Fred Dalkey, it also celebrates Sacramento, a city of incredible artistic accomplishments that the Crocker will continue to recognize and explore. I would also like to thank each of the many lenders to the exhibition and the individuals and organizations who contributed to this publication. As always, the City of Sacramento and the Co-Trustees of the Crocker Art Museum make these projects possible.

ACKNOWLEDGEMENTS

SCOTT SHIELDS, CURATOR OF ART
CROCKER ART MUSEUM

The numerous organizations, individuals, businesses and artists in the community that have come forward to pledge their time, resources, and artwork to this exhibition and catalogue are a testament to Fred Dalkey the artist and Fred Dalkey the person. Many of these supporters have been Dalkey champions for years. Even those who have lost contact with the artist in the ensuing decades since they purchased his work still speak in glowing terms about the positive effect that Dalkey's art has had on their lives, and of their fond memories in meeting him. Perhaps most tellingly, Dalkey's supporters include a broad group of artists and former students, many of whom are now creating important work of their own. Their readiness to endorse their former mentor, even though Dalkey's style may be vastly different from their own, bears witness to Dalkey's enduring influence as a teacher. Other individuals have come forward simply as long-time friends of the artist, and of his wife, Victoria. It was through this broad community support, coming from nearly everyone fortunate enough to have had contact with the Dalkeys, that this project is made possible.

Many individuals have played specific and pivotal roles in making this exhibition a reality. Because underwriters to the catalogue were legion, they are listed separately, but we wish sincerely to thank them all. Key players in catalogue fundraising efforts include Phil and Marilyn Isenberg, Anne McHenry, Maurice Read, and Paul LeBaron Thiebaud. Rakela Company, especially catalogue designer Jaime Ferguson, have enabled this publication to be most beautifully realized.

Lenders to the exhibition were unwavering in their willingness to part with their works of art, and many must also be thanked for making numerous trips to the Crocker to deliver art for photography. Artist Chris Daubert, spent many hours making sure that the catalogue reproductions were true in color and clarity to the original work. Finally, every member of the staff of the Crocker Art Museum was committed to the project. Their contributions include curatorial direction, educational components, installation, fundraising, and publicity.

Thanks are due to Richard Wollheim for permission to reprint his essay on Fred Dalkey's drawings, to Charles Campbell, Elisa Borrego, and Pam Melville for their assistance in tracking down collectors, and to Glenna Campbell and Kelly Purcell for their help in locating existing photographs of works shown at the Campbell-Thiebaud Gallery. Chris Iwata, Dean of Humanities and Fine Arts at Sacramento City College, and Chris Reding must also be commended for their efforts in securing a sabbatical leave for Fred Dalkey, so

that the artist could devote his full energies to working on the exhibition.

Finally, this project benefited from the labor of an extraordinary support team that gave generously of time and energy in coordinating all aspects of the exhibition and publication. Julia Couzens, Victoria Dalkey, Chris Daubert, and Wayne Thiebaud each contributed many hours to the project, as did project coordinator Susan Willoughby, who also cheerfully assumed the critical, but oftentimes unenviable roles of chief fundraiser and catalogue editor – for this, we thank her. Victoria Dalkey was invaluable in assembling the details of Fred's life and artwork. And it should come as no surprise that Fred Dalkey himself was also involved every step of the way. His presence and direction were both welcome and appreciated.

An Appreciation of Fred Dalkey

Wayne Thiebaud

Working painters are aware that painting is not simply a pleasant distraction. It is a powerful attraction akin to an addiction. Fred Dalkey is a painting and drawing addict.

Co-existing with this compulsion is a deeply embedded involuntary personal skepticism – a unique hesitancy about one's own work and its appropriateness. These kinds of thoughts are the reflection of a high intelligence dedicated to aesthetic ideals and skilled craftsmanship which we are privileged to enjoy in this excellent retrospective.

A search for excellence demands experiment and risk along with a deep critical sense based upon formal concerns. These complex preoccupations are the means by which Fred's special achievements have been made. So after all, his skepticism has served him well, for we are the beneficiaries of his celebration of beautiful, beguiling enchantments in so many silent visual worlds.

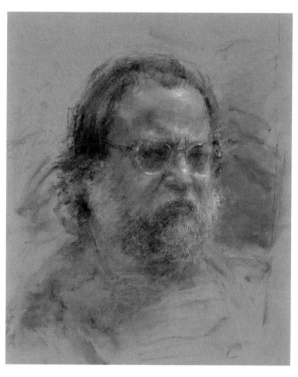

Self-Portrait, 1993
charcoal and white Conté on paper
19 1/2" x 15 3/4"
Collection of Mr. and Mrs. James V. de la Vergne

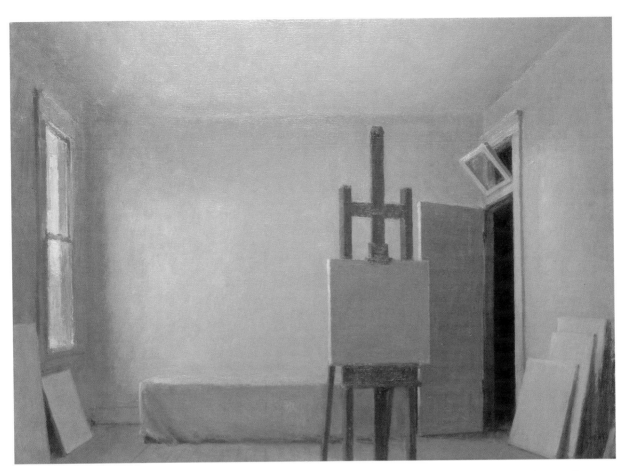

Annunciation: the White Studio, 1991
oil on linen
20" x 28"
Collection of Elizabeth and Mason Phelps

Fred Dalkey and The Structure of Silence

Peter J. Flagg, Ph.D

Samuel Beckett used to claim that the reason he wrote was to not have gone through life "without having left a stain upon the silence." Fred Dalkey seems to approach his art with a similar view towards creation: he makes art as an affirmation of existence. This is altogether fitting for an artist who began his career in the often misunderstood métier of portraitist, experimented somewhat belatedly with abstraction, and spent the better part of a decade painting cityscapes and landscapes devoid of human presence. Indeed, the human figure, and at times its absence, has served as the artist's touchstone to which he has repeatedly returned throughout his career. In his most spectacular series of figurative subjects, begun in the early 1990s, Dalkey paints and draws the female form enveloped in near-tangible atmosphere. The surround of colored light animates

> "I don't know,
> I'll never know,
> in the silence you
> don't know…"
>
> –Samuel Beckett,
> *The Unnamable*, 1949

his compositions in a way that his passive, semi-anonymous figures do not, upsetting the normal balance between figure and backdrop. This "structure of silence," of individuals competing with the atmosphere for compositional space and of the fusion of the material world with the timeless and the spiritual suggest that identity itself is the recurring theme of his work.

The satisfaction derived from looking at a painting or drawing by Fred Dalkey comes with the implicit understanding that we are confronting a not wholly generous appraisal of the human condition. There is nothing especially complex about his working vocabulary of subjects – faces, nudes, urban and rural vistas – they are obvious and comforting in their predictability. The artist's technical mastery and his unobtrusive methods of observing and rendering the human figure satisfy

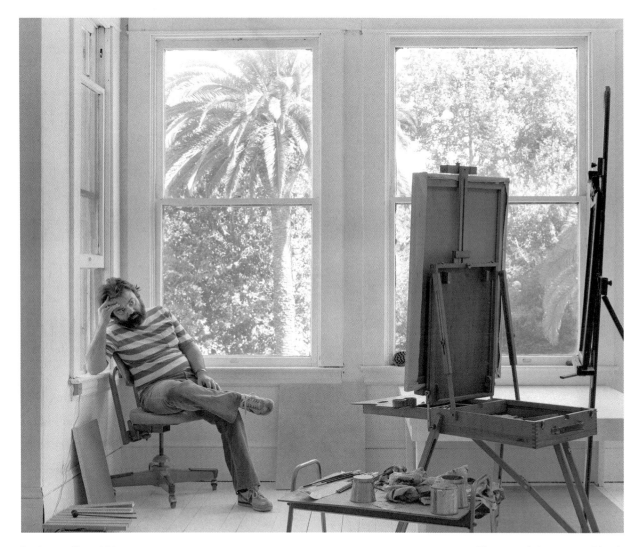

In the studio, 1980 Photograph by Kurt Fishback

and reassure without resorting to theatrical gestures, yet on closer inspection this is a slyly subversive artist. These same portrait subjects, empty street scenes, and nudes in the studio tug with a quiet urgency that hint at skepticism, despondency, and social alienation all the while maintaining the decorum of the properly conceived and meticulously executed artist's motif. The resulting tension between subject and signifier, between deadpan observation and interpretive rumination, forces us to see with the artist's own self-searching ambivalence towards his material.

He was never an avant-garde painter. The major influences impacting his formal means and narratives all fall well within art historical tradition and outside modernist and post-modern orthodoxy: the Hudson River School and American Luminists, the tonalism of Rembrandt and the atmospheric renderings of the Impressionists, American modernism and Bay Area Figuration of the 1950s and 1960s. He works in relative isolation, a design for living dictated in part by geographical limitations – he seldom leaves Sacramento – but more pointedly by temperament. His works allude directly neither to the rampant consumerism nor to the political or social issues that serve as the wellspring for much of postwar American art. He subscribes to no theory and follows no trend other than his own intuition and artistic inclinations. His paintings and drawings are the products of such intense intellectual focus that they often obviate the need for explanation as to their precise meaning.

A Fred Dalkey painting or drawing is no more or less than a mirror of Fred Dalkey the individual. In place of modishness, Dalkey provides sureness of execution and subtlety of touch. Instead of conventional irony, he gives us an admixture of self-investigation and visual truth. He states he believes in "the artist's responsibility to remain civil in an uncivil society." If these are old-fashioned virtues, they are also among the values that place the artist's work squarely within the Western tradition of figurative art. Now that modernism and the very notion of an avant-garde have begun to lose their pre-eminent position as a mode of aesthetic discourse, Dalkey's place within the framework of art history seems obvious, even inevitable. He is, above all, an exponent of the humanist tradition whose work is based in observation and sensory perception and whose silences, thematic and structural, are as conspicuous as his visual language.

He was born Fredric Dynan Dalkey, the second of three children to Susan Dynan and Frank Dalkey, on February 22, 1943.[1] During wartime, the Dalkeys occupied a flat on 24th and C Streets in Midtown Sacramento, a neighborhood of sprawling multi-family homes and tall elm trees. The family relocated to the New Helvetia housing development in 1945 and once again, in 1950, to the Fruitridge area on what was then the southernmost district of the city. From his youth, Fred wanted to be a "serious artist" and spent hours of his free time copying the cover designs of record

jackets – an early "portrait" of Arturo Toscanini survives – and taking inspiration from the sloughs, swamps, and fishing grounds in the low-lying Sacramento Valley. At the age of fourteen with the support of his parents, he began taking drawing lessons from Abraham Nussbaum, a portrait painter and former violinist with the Vienna Philharmonic who had taken up residence in California after the Second World War. Nussbaum was decidedly Old World in his manner and his training, and his influence on his pupil was critical: from Nussbaum Fred learned not only the fundamentals of drawing, composition, and color but also a way of seeing that was grounded in anatomy and proportion, a European sense of finish (especially from Rembrandt whose painting of *A Jewish Rabbi* he copied), a love for the medium of paint, and the centrality of the human figure.[2]

Fred became a student at Sacramento City College in 1960 where he studied with such charismatic teachers as Gregory Kondos and Larry Welden. Things proved more difficult, however, after he transferred to Sacramento State in 1963. Many of his professors and fellow students saw his work as academic and old-fashioned and he felt undermined by their response to his work. These experiences left him with feelings of anxiety and isolation due to his classical training and a profound sense of dissatisfaction with his own work. (To this day he destroys approximately one third of his output.) During this time, Fred minored in philosophy. He also received some of the best professional advice and encouragement of his career from his colleague, Nancy Gotthart. One day Fred complained to Gotthart that he was having trouble getting the color right in a painting. Gotthart immediately shot back, "Why don't you get it wrong?" Fred now challenges his own students with this advice.

While working toward his degree, Fred supported himself employed as a guard at the Crocker Art

Portrait of Toscanini, ca. 1956
graphite on paper
11" x 8 1/2"
Collection of Fred and Victoria Dalkey

Museum. With hours spent walking the galleries, Fred had ample time to familiarize himself with the Crocker's Old Master collection of paintings and drawings. In 1968, the Crocker mounted an exhibition of paintings from several French museums, featuring such celebrated works as Nicolas Poussin's *Orpheus and Eurydice*, Hyacinthe Rigaud's *Portrait of Louis XIV*, Antoine Watteau's *Gathering in a Park*, Jean-Baptiste-Siméon Chardin's *House of Cards*, and Jean-Honoré Fragonard's *The Hay Wagon*.[3] Fred remembers being especially struck by the elaborate conception of space in the Poussin and the delicate solemnity and lyricism of the Watteau. In 1969, Fred began his long association with Sacramento City College where he has taught drawing in the Department of Art ever since.

Self-Portrait without Shirt, 1980
oil on linen
30" x 20"
Collection of Fred and Victoria Dalkey

known." To know something about Fred Dalkey one begins with his self-portraits. He made his first self-portrait under the guidance of Abe Nussbaum around 1958. Around 1975, he also acquired a book, *Five Hundred Self-Portraits*, which has served as a steady source of visual information for the artist up until the present day.[4] For Fred, the appeal of the self-portrait stems from the simple fact that it is an "easy model" with which he feels free to experiment. Fred refers to the self-portrait genre as his "touchstone to content," but he is hard-pressed to say what, if anything, such works reveal about him. In his 1980 *Self-Portrait without Shirt* (at left) the artist looks out defiantly at the viewer, a bare-chested and sulking figure akin to Francisco Goya's *Colossus*, but without the sfumato and in the cold light of day. The self-image hints at an imposing physical stature the artist in life does not possess and at a force of character that he does. In this compelling work Dalkey the artist challenges the viewer to see Dalkey the man

When asked the importance of professional visibility, Fred cites the painter Balthus who, in being asked for a biography, supplied the remark, "Balthus is an artist about whom nothing is

as a coherent, integrated being while at the same time denying access to his inner life.[5]

The *topos* of the defiant artist as an alienated hero living on the margins of society was a staple of much of nineteenth century French painting, beginning with Neoclassicists and Romantics like Jacques-Louis David and Eugène Delacroix, and extending to Realists and Naturalists like Gustave Courbet, Edward Manet, and Edgar Degas. Fred himself observes that the nineteenth century was a period of "the blossoming of the notion of self." Like Degas, Fred is mainly interested in recording external appearance rather than probing the personality of the sitter. Yet, in looking at Fred's 1980 *Self-Portrait* one comes away with a very distinct impression of an individual psychology that simmers with repressed emotion. It should, therefore, come as no surprise that the decade leading up to this *Self-Portrait* was a difficult one both personally and professionally for the artist. Fred tempers the emotional tenor of the painting with chestnut and cream tones that give the work an academic flavor. As a result, while there is very little about *Self-Portrait* that could not have been painted a hundred years earlier, the painting nonetheless succeeds in turning on the psycho-logical impact of the moment.

None of Fred's subsequent self-portraits are as uncompromising in their assault on viewer sensibilities. Most, including the strangely evoca-tive *Self-Portrait by an Easel* (page 17), work their magic by subordinating the image of the artist to the surrounding atmosphere. As such, self-likeness becomes a motif around which other constituent elements are arranged. In *Self-Portrait by an Easel*, Fred paints himself standing on the same mark of the studio floor where he positions his models. This implied subjugation of ego seems worlds apart from the confrontational psychology of the 1980 *Self-Portrait* – or perhaps, the later painting seems emotionally cool simply because we cannot see the artist's face. Other self-portraits like the drawing in the de la Vergne collection (page 8) reveal an intense and lively character captured in swift, curvilinear strokes of chalk, but even here the artist's features seem to take second place to the sparkling light that animates the sheet. As in the paintings of Rembrandt whom the artist reveres, Fred's self-portraits are grounded in observation of light rather than self-expression. The figure of the artist in *Self-Portrait by an Easel* stands midway between the canvas and the window against which the figure is illuminated. If the painting is the end result, light is the source of the artist's inspiration and what gives the tried and true subject of an artist in his studio a topical freshness and the feeling that one is witnessing a unique moment in time.

Fred's 1980 *Self-Portrait* was an act of sheer bra-vado, a way of encapsulating and presenting an edited version of himself to an unspecified audi-ence. In *Self-Portrait by an Easel* and in his most recent *Self-Portrait with Hands on Hips* (cover), he paints with a self-assurance that is real rather than feigned. The new self-portrait shows Fred standing

by the window in his studio, arms akimbo, dressed in a blue T-shirt and suspenders, looking directly out at the viewer. The artist is older, thinner, and grayer in this most recent effort, but the facial expression is both frank and familiar. An intersection of windows and walls consolidate into a cruciform structure that hovers lightly like a mystical revelation behind the artist. "There are practices," the painter remarks, "you learn to use to the best of your ability to respond to nature." Among these are a sense of color and atmosphere – predominantly cool and spacious here with an absence of chiaroscuro or anecdotal detail – but also ambition, curiosity, and a concrete notion of what a painting should look like. *Self-Portrait with Hands on Hips* is part likeness and part self-assessment of an individual for whom art is equally a passion and a continuous source of enlightenment.

Many of Fred's paintings and drawings from his earliest works to the latest self-portrait are based in traditional practices of composition. After priming the canvas, Fred typically begins with a charcoal underdrawing that captures the general outlines of his subject. This is followed by the application of grisaille establishing spatial and tonal relationships and then underpainting which solidifies those relationships. The surface colors that come last add anecdotal detail and visual appeal but essentially have no impact on the artist's conception of space, anatomy, or proportion. Fred also frequently resorts to principles of selection in which he chooses the most evocative light, the most intriguing facial features, or the most telling elements of a

landscape recombined on the paper or canvas for maximum effect. Thus, with the exception of some of his drawings, none of Fred's works are ever completed on the spot with the aim of recording a motif in actual time. Instead, his works are the product of reflection and of execution over several hours, days, or weeks. Many of his motifs come from his sketchbooks of individuals in public places he observes and sketches on the spot, from memory, or in combination of the two. In the studio Fred is able to approximate the light and the impact of the first sitting much as Flaubert did in writing *Madame Bovary*: by returning to the same place at the same hour every day. A work like *Self-Portrait by an Easel*, therefore, transcends the limitations of time in that it synthesizes not only the artist's actual experiences, but also his memory of those experiences.

Fred's early gift for mimesis and his training as a portraitist led to many commissions in the 1970s and 1980s. Like legions of artists before him, he has always felt ambivalent towards commissioned work, viewing it as a harness on his own creative goals as well as an opportunity to make money and demonstrate his skill. Fred's solution to this dilemma was a simple one that drew upon already existing artistic impulses. Rather than paint flattering likenesses, Fred typically visualizes his sitters as "compelling images" in a compositional unit. In this manner, the figurative images are largely undifferentiated from their surroundings and interlock with the compositional and thematic structure of a painting as in a Cézanne

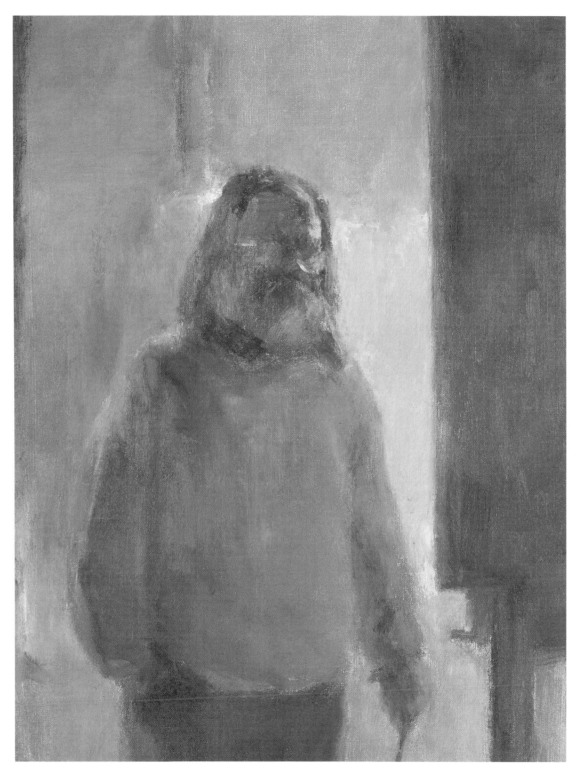

Self-Portrait by an Easel, 1996
oil on linen
24" x 18"
Collection of Carol Ross

landscape. The problem is then not one of capturing likeness so much as of balance and integration. Fred cites his 1972 portrait, *Karen Onstad by a Window* (page 55) as a painting in which he believes the red velvet dress of the sitter is not wholly integrated into the space. In later portraits, he is careful to give equal weight to all elements of the composition. This method of lessening the distinction between subject and backdrop can result in a certain coolness that precludes intimacy with the sitter.

Around this time, Fred was experimenting with the idea of eliminating contrapposto from his figurative paintings and presenting his subjects in frontal, symmetrical, and upright poses character-istic of Egyptian relief painting or Archaic Greek sculpture. This "Egyptian pose," as Fred refers to it, is readily apparent in his portraits of Karen Mast (opposite) and of his wife, Victoria Dalkey, (page 65) both of whom seem to look directly at the viewer with a vulnerable yet penetrating stare. As the viewer contemplates the sitter of the painting, the sitter looks back with a similar level of curiosity establishing a powerful connection between the two. The v-neck line in the portrait of Victoria Dalkey adds a further hieratic touch and also serves as a rebus for the sitter's name.

The rigid formality of these works stands in contrast to the natural, flowing contours of the Conté crayon drawing of Victoria done around 1985 (page 66). The drawing represents the sitter seated out-of-doors at Stinson Beach reading an unseen book. The book reflects the intense light

of the ocean setting that, in turn, takes form in the complex pattern of light and shading that compose the face. This is a suave and elegant portrait study, one of the most satisfying from the period that radiates not only the contentment of the sitter, but the artist's ability to create a vivid likeness on the spot.

To visit Fred Dalkey at home is to take a journey into the life and mind of the artist. He and his wife Victoria and their son Emile reside in a two-story carpenter-style house on a leafy street in East Sacramento. Crepe myrtles line the walk up to the sloping porch that looks back out on to a street of houses, apartments, and a school. Their cat, Tibris, prowls the perimeter of their house inciting the blue jays to chatter whenever he emerges from hiding. Inside, the house has the informal comfort of an American academic with its dark woods, Oriental rugs, capacious leather chairs and sofa, groaning bookcases, pendulum clock, and artwork that includes not only paint-ings by Sacramento area artists, but also European etchings, Japanese prints, Pre-Columbian and New Mexican pottery, and a range of musical instruments. Portraits of Victoria and Emile hang over the hearth; unmatted drawings that span the artist's career lie about or in cabinets.

At home, the artist is both industrious and at ease, producing one or more drawings a day from the cozy embrace of the living room sofa. His working method for years involved the ingestion

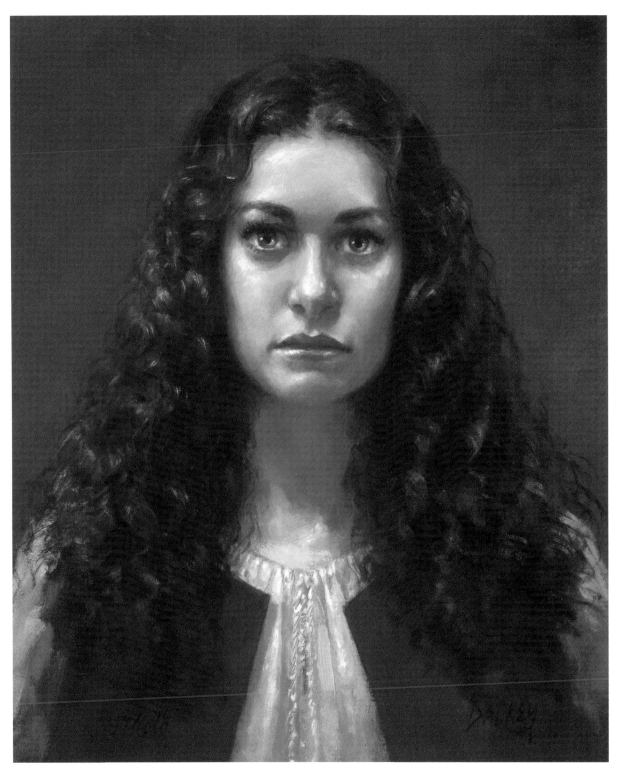

Karen Mast, 1976-78
oil on linen
17" x 14"
Collection of David and Karen Mast

of caffeine, nicotine, and martinis, which Fred calls the "Buñuel diet" in homage to the late Spanish director who claimed to exist on this regimen. Since a heart attack in 1999, Fred now favors *pu'er* tea, ginger cookies, and California roll, working in the early mornings and evenings with afternoons reserved for teaching, rest, and various intellectual pursuits. When not at work, he spends time reading and discussing literature (*Moby Dick* and *The Iliad* are old favorites), listening to Bach, Beethoven, Sibelius, and rural American folk music, playing the guitar, or reading poetry out loud with his wife Victoria.

A quiet and composed speaker, Fred talks with concentrated intensity about what moves him in art. "Art has the ability to survive the detritus of the past," he observes. "I look for work that is durable, that is capable of transcending time." In order to achieve this moment of transcendence in his own work, Fred begins his day in the pre-dawn hours when his mind is alert and yet fluid, capable of responding to outside stimuli but equally responsive to drifting into a "state of no-thought." In this liminal area "outside of your control" images arise that form simple colors and shapes and that, in turn, establish basic relationships from which the artist arrives at his composition and palette. Often, these relationships resolve themselves into groups of four, i.e., the four directions, the four elements, the four seasons that give the painting or drawing a sense of balance or completion. Fred also responds to the ambient light during the "no-thought" state as well as to the sounds of nature. "Nature hums,"

he remarks. "The sound of air" mixed with properties of light create an envelope of "sound color," in the artist's words, at which point the work becomes "resonant." Fred acknowledges an element of Taoism and of Zen Buddhism in the development of his aesthetic philosophy but insists that his work is not the product of religious conviction but of direct engagement with nature. Like Taoist and Zen artists, however, he sees himself as a participant in his own work rather than its sole creator, and it is by responding to the "sound color" of the subject that he is able to give physical expression to something that already exists.

Tapping into the vatic voice represents a kind of intelligence that eschews intellectual constructs or theoretical underpinnings. Fred's work is intimately connected to the act of seeing and is faith-based to the extent that he is willing to improvise and take chances. In the 1970s he became increasingly involved with the question of what makes a painting a painting leading him to experiment with abstraction. While some of these works contain allusions to human or animal figures, they are exercises in chromatic harmony and the arrangement of forms as much as they are content-oriented abstractions. This new phase coincided with a tenure dispute at Sacramento City College, where Fred had been teaching since 1969, and that took nearly eight years to resolve. He admits that much of his work during the seventies was, accordingly, fueled by anger over his tenuous job situation. The paintings from this period show the artist as a magician of striking

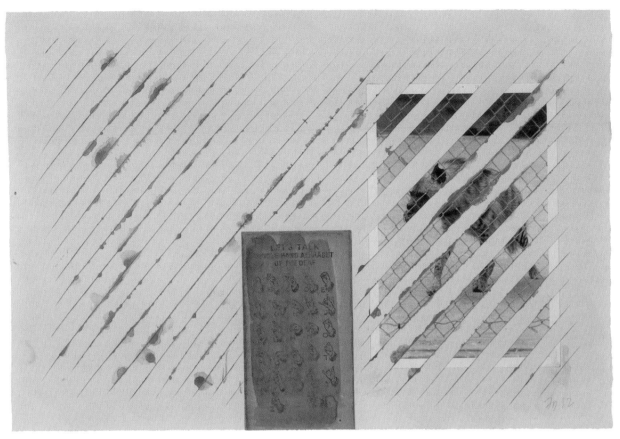

Let's Talk, 1972
mixed-media on paper
7 1/2" x 11"
Lent by the artist

delicacy and invention, but they also convey his anxiety.

Fred's experimental period took four major directions, each of them surprising and generally short-lived. The "zoo series," begun in 1972, comes from a period when the artist had essentially stopped painting. While teaching a summer class, Fred took a group of students for a field trip to the Land Park Zoo. While the students studied and sketched the animals on display, Fred observed the fretful monkeys and pacing timber wolves and hyenas and sketched them. His

collage, *Let's Talk* (above), captures that sense of trapped energy as seen through wire mesh. The design here is deliberately crude and the palette unusually somber evoking sympathy for the caged hyena while hardly diminishing its air of menace. The work is essentially a self-portrait that captures the artist's state of mind at the time.

In 1973, Fred also painted *The Convalescent Hospital* (page 57), a major work that summarizes the aesthetic and intellectual preoccupations of his career thus far. With its bold composition, methodical stages of preparation, and topical

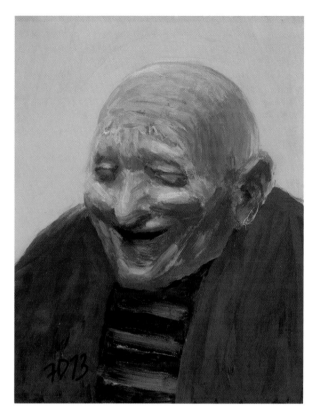

*Convalescent Hospital Study
(Smiling Man in Red Shirt),* 1973
oil on panel
8" x 10"
Collection of Marilyn and Phil Isenberg

theme, it is his *Raft of the Medusa.* The painting, representing a group of elderly individuals in a convalescent home, stems from his experiences in visiting the hospital where Victoria's mother was residing, and evolved out of the sixteen oil studies Fred did of faces of the hospital residents executed from memory of those visits. The oil sketches refer to specific people in the hospital and as a group form, according to Fred, "a kind of perpetual puzzle of things you don't want to look at." In the finished composition, Fred invents a quasi-Cubistic format in which the hospital residents are painted from multiple viewpoints and shown adrift amid a series of tilting planes and surfaces. This fragmentary approach diffuses the narratives and some of the pain associated with them by focusing on spatial relationships and broad zones of color. Fred claims he painted *The Convalescent Hospital* "as bluntly as I could" to make the break with his formal training and education as pronounced as possible. By examining the American way of dying, Fred also found an outlet for his anger that, he claims, is "a good place to be as an artist."

Many of Fred's most enigmatic works of the 1970s and 1980s bear literary or mythological titles like *Faust's Study, Danae,* or *Persephone in Minnesota* (page 60 and 61). Although Fred was familiar with their literary antecedents, none of these paintings are illustrations of a text. They are invariably conceived as studies in light and its dissolution centered around a motif. The so-called *Faust's Study* with its female figure alluding to Helen of Troy, for example, was inspired not by Goethe or Marlowe, but rather by a Rembrandt etching of Faust in which the figure is modeled by the intense and radiant light from a multi-paned window.[6] *Persephone in Minnesota* was executed shortly after the death of Fred's mother. It was also in part fueled by a Bob Dylan song, *Never Say Goodbye,* that Fred was playing and replaying at the time and came to feel had "to do with something crucial of the way things are." In classical myth, the annual departure of Persephone for the underworld

marked the beginning of winter. In the painting, the figure at the bottom appears bent under a vast world of snow, a metaphor for the weight and oppression of grief. The Persephone title and the allusion to the Minnesota of frozen lakes in the Dylan song both provide overlapping cultural contexts for what is effectively a personal expression of a sense of loss.

Fred's most abstracted works of the 1973-1980 period all bear titles indicative of phenomena or emotional states like *Chance, Mumbling* or *Passion*. In these instances, the works and their titles recall specific individuals and the situations associated with them. They represent, once again, an expansive notion of portraiture rather in the way Edward Elgar created musical sketches of his friends in *Enigma Variations*. *Mumbling* (page 43), for example, serves both as the artist's response to the illness of his mother and as a meditation on the arbitrariness of language. With its chalky white pastel drawn on black paper, it has the raw appearance of an exposed negative. The letters that dance around the perimeter of the composition combine randomly into phonemes and morphemes that fail to become fully articulated words. The composition is shot through with a kind of internally generated light radiating from the central image that is as fragile as it is otherworldly. *Mumbling* addresses the miracle of language as well as the tragedy when the ability to use it is lost.

Passion (page 64) is undoubtedly Fred's most difficult painting of this period, one in which the viewer is accorded more the role of a bystander than a participant. And yet, it is a pivotal work in the artist's career in that it summarizes many of his preoccupations of the previous decade while serving as an indication of his future development. The strangely androgynous central figure stands in a kind of "light chamber" as do many of his subsequent figurative subjects and with its emphasis on sensibility over descriptive content it becomes a kind of gruesome variant of a self-

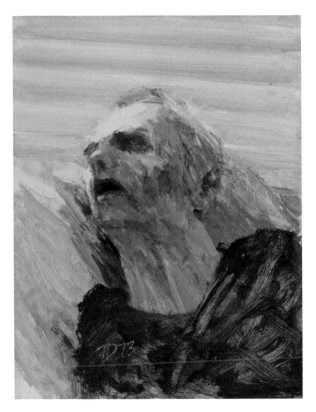

*Convalescent Hospital Study
(Man with Venetian Blinds)*, 1973
oil on panel
8" x 10"
Collection of Marilyn and Phil Isenberg

portrait. The alien-like facial features, crown of antlers, and use of red to highlight the hands and genitals disturb as well as fascinate. Victoria believes that the work represents "the completion of self through the embracing of the feminine." By giving vent to such feelings in *Passion*, Fred's work comes full circle and he is able to find release from a decade of self-doubt.

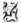

On another day, Fred is seated in the dining room doing a portrait sketch of Victoria. The room is sheltered from the intense summer light by shutters. Victoria sits and poses with the ease and fortitude of someone who has done this sort of thing before. Fred uses a crayon holder that, initially, he holds high up on the shaft for freedom of handling. His movements are light and rapid covering the entire sheet with broad strokes of the crayon. Later, he holds the shaft of the holder at its lower end and bears down more firmly on the sheet to limn the details of Victoria's face. He alternates use of the crayon with a stump to blend the tones, occasionally erasing where the network of lines is too thick or the tones muddied. Gradually, the image seems to emerge as if sculpted from a rock, but the portrait, in fact, owes its success to careful regulation of the values.

The completed drawing is not merely a technical feat, but a recording of an artist's response to his model and Fred is aware that it is the model as much as his method that dictates the character of

the work. In the case of Victoria, the drawing radiates a patient and sympathetic understanding between artist and subject. Other drawings find their individual quality in the body language of their respective models. Stacey, for example, is strong and athletic; Julie radiates vulnerability; Diane with her regal bearing is the "queen of the models." In the studio, each model works a three-hour shift. While to some extent they are all neutralized and generalized by the light, their bodies respond differently to the atmospheric effects and convey lightness or gravity to varying degrees. It is a moot point whether this results strictly from observation or from the artist's perception and interaction with his model. As Fred remarks, "We don't look at things with our eyes; we look at things with our habits. I try to short-circuit this habitual mode and see as directly as possible."

Fred's Conté crayon drawings represent a kind of formalism rather than a social image for which he cites the drawings of Georges Seurat, Thomas Eakins, and Francis Bacon as precedents. According to Fred, each possessed the uncanny ability to blend figurative imagery with background, giving them equal weight so that the intensity of portraiture was submerged into the wholeness of the image. Seurat used Conté crayon to achieve subtle textural effects in his figurative studies and drawings of models. Like Seurat, Fred makes use of the grain of the paper so that the image is not composed of solid tones but atomized into tiny dots as in a mezzotint or a Neo-Impressionist

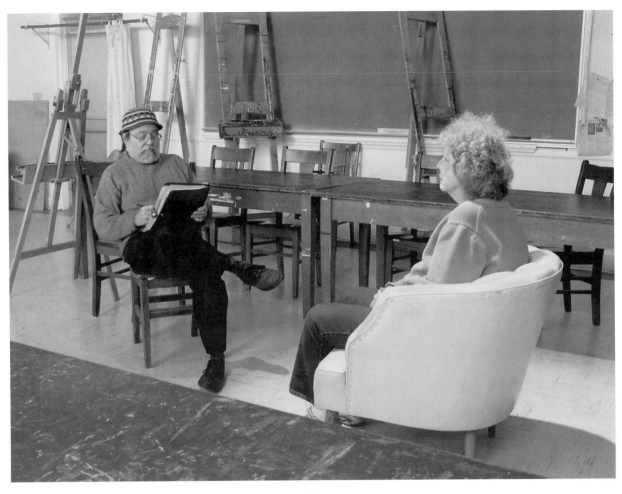

Fred sketching Victoria in classroom at Sacramento City College

painting. In *Julie Rising* (page 92), for example, the model supports herself with her arms as she rises out of an armchair. The chair, centered on the sheet, is the darkest element of the drawing and acts as a foil to the contours of the light-modeled figure. The source of illumination comes from the right and leaves a large portion of the torso in shadow. Fred uses the stump sparingly to attain a sense of atmospheric balance, but it is really the paper where it comes in contact with the Conté crayon and where it does not that creates the image and sets the mood. The effect is soft, transporting and otherworldly.

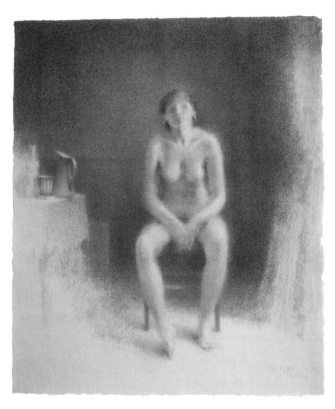

Stacey with a Morandi Still Life, 1994
sanguine Conté on paper
12 1/4" x 10 1/2"
Collection of Morgan Flagg

In other drawings, the artist places his subject in juxtaposition with objects or studio props that blur the distinction between animate and inanimate subjects. In *Stacy with a Morandi Still-Life* (above), Fred sets his model alongside a still-life of pots and jars that have the laconic force of the Italian master's work. The contrast of forms with their varying shapes and surface textures allows the artist the double-trick of treating the model as a still-life subject while imbuing the objects with a ghost of humanity. *The Old Floating Hat Trick* (page 51) features an Eakins-like female figure staring out at the viewer and oblivious to the top hat floating in the air to her left, an apposition of the solidly real and the patently surreal. And yet, it is the hat that has weight and substance and the figure of the model that is delicately wreathed in a halo of light as if the figure and object had exchanged densities. According to *San Francisco Chronicle* critic Kenneth Baker, such drawings render "light and shadow, atmosphere and substance, without line and with as little discontinuity as possible."[7] This feeling of continuity across the entire surface of the sheet is one of the distinguishing characteristics of Fred's work.

In *Life Class* (page 91), Fred addresses the themes of *memento mori* and *Totentanz* with characteristic bite and dark humor. The drawing features another

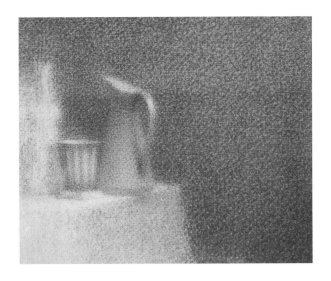

nude model, this time confronting a skeleton in a reflective mode rather like the shepherds in Poussin's *Et in Arcadia Ego*. In either case, death is not so much a source of horror as of metaphysical speculation. Fred's fascination with skeletons and skulls dates to around the age of four when, in order to discourage him from playing in the refrigerator, his mother placed a book there open to an image of a skeleton in order to frighten him away. While skeletons and skulls may carry a certain emotional charge for the artist, the viewer is likely to be struck instead by the soft tonal values in *Life Class*, achieved by dragging the crayon across the grain of the blue-gray paper. The content of the drawing is, according to Fred, the product of "the intensity we bring to things." But can a baseball carry the same level of intensity?

Most of Fred's still-lifes are of recent vintage. Like his work of the seventies, his drawings of base-balls, balls of string, violins, ginger jars, and soy sauce ewers contain threads of symbolic narrative. In plotting this new direction, he acknowledges a

debt to the still-life subjects of Wayne Thiebaud, who gives insignificant objects narrative power, and to the *trompe-l'oeil* painting of Michael Tompkins, who meticulously "paints the same cast of characters over and over again." The human presence is never far from Fred's still lifes, as is evident in the case of the violin with its physical resemblance to the female form and as a metaphor for the creative and/or performing artist. Fred takes this kind of direct symbolism to its logical conclusion in a 2001 Conté drawing of a soy sauce ewer, ginger jar, and a baseball (page 101). The three objects, while distinct in their features, form a kind of family unit not unlike Fred's own. Each object is consummately drawn with the terse precision of a Morandi or a Chardin. Without context other than the immediate surround of light and shadow they attain a weighty physical presence. Self-contained and self-regarding, Fred's still-life objects hold our interest and galvanize our thoughts through their simple eloquence and astonishing beauty.

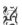

Among Sacramento audiences, Fred is well known for his landscape and cityscape subjects. These paintings seduce with their amazing power and candor as well as for the solitary vision they manifest. The special appeal of these rural and industrial scenes lies not only in their familiarity as vistas, but equally in their evocation of the work of other landscape and cityscape artists of the last two centuries. Fred's *Elk Slough* (page 72), a microcosm of stunted cottonwood trees grown up around a

watery byway shrouded in early morning mist, has Impressionist roots in the river scenes at Giverny of Claude Monet. Similarly, *Bannon Slough* (page 41), a tributary at the confluence of the American and Sacramento Rivers, has antecedents in the work of the Hudson River School with its pious reverence for untarnished nature. Fred's attraction to such places is, in part, an acknowledgment of these artistic sources, but it also comes out of his love of swampy places dating to his childhood when he used to spend hours fishing.

His slough and river paintings also afford him the opportunity to play with dense, opaque textures consonant with his love for the medium of paint. This feeling for the medium comes to the fore in a painting like *Land Park Pond* (opposite). The time is 5:30 a.m. when the sun has yet to rise and the setting is shrouded in gloom. The heaviness of the air is approximated by the thick colors and textures of the paint, and the absence of a human presence infuses the landscape with existential loneliness. Unlike rural nature, Land Park is man-made for the refreshment of urban visitors and, therefore, all the more desolate for their absence.

In keeping with Fred's predilection for working in the early morning or late afternoon, none of the river paintings depict the bright sunlight of midday, a time when Fred finds the light "too intense" and lacking "that reverie of time" or feeling of introspection conjured up by deep shadows or rising mist. Following Monet's example, Fred often returns to the same spot on successive days to capture the specific lighting

effects at a particular time of day or memorize them for future use in the studio. At times he uses sketches, notes, or photographs to refresh his memory and also uses principles of selection to combine the light of one place or time with a completely different setting. While the atmospheric effects of *Elk Slough*, *Bannon Slough*, and *Land Park Pond* appear to have been recorded on the spot, they are in fact constructs of different experiences rather than direct transcriptions of nature.

"The process of being alive," he observes, "is to experience." For Fred the sense of being alive is best savored in the pre-dawn hours when the city neighborhoods are devoid of human presence. This neutron-bomb approach to the street life of greater Sacramento is not without its charms as evinced by the finished work, but it is equally unexpected coming from an artist who has devoted the bulk of his career to the exploration of the human figure. Fred likes to cite the Paris scenes of the photographer Eugène Atget and works like *Sunday Morning* by Edward Hopper as examples of compelling urban images that exclude activity. More pointedly, Fred feels that there is an underlying "toughness" to California valley towns like Sacramento where, due to its reputation as a cow town, people are forced to invent their own culture. According to Sacramento-born writer Joan Didion, it "is a place in which a boom mentality and a sense of Chekhovian loss meet in uneasy suspension; in which the mind is troubled by some buried but ineradicable suspicion that things had better work

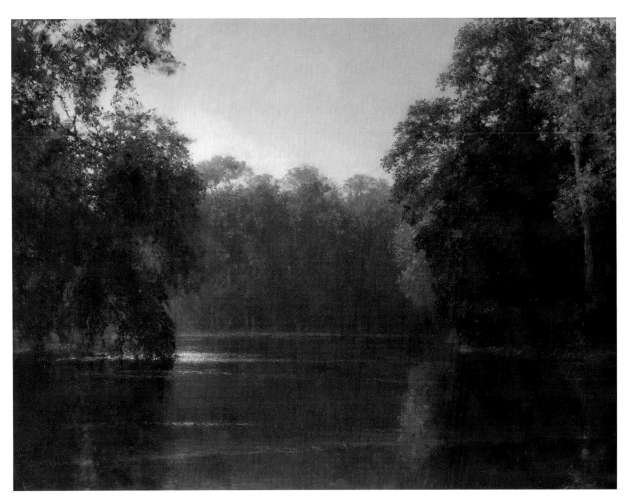

Land Park Pond, 1988
oil on linen
36" x 48"
Collection of Susan and Thomas Willoughby

here, because here, beneath that immense bleached sky, is where we run out of continent."[8]

Fred's sense of place is so precise and so trenchantly observant that one wonders what Sacramento would be like without his level gaze fixed upon it. A little painting like *Driving Down 4th Avenue* (page 70) with its canopy of trees filtering the sunlight is a miracle of economy and atmospheric effects. The feeling of rapture is amplified by the absence of any hint of human presence on what is, after all, a city street. Bleakness and beauty intersect at *27th and P* (page 71), a painting that looks west down the tree-lined axis of P Street to the setting sun. The presence of palm trees makes a sultry reference to Sacramento's "Mediterranean climate," and once again at this hour there is no traffic on what is normally a busy thoroughfare.

Like many American artists from the earlier part of the twentieth century, Fred gravitates to the industrial areas of the city and to the bizarre juxtapositions of form and materials to be found there. His vision, unlike that of many of his predecessors, however, is not a celebration of industrial power or a condemnation of urban blight, but rather an observation and summation of its varying light properties, surfaces, textures, and shapes. The area around Stockton Boulevard and the train tracks along R Street, a neighborhood of feed stores, warehouses, and auto body shops, has the bygone appeal of a depopulated Midwestern town time has passed by. In fact, the neighborhood is well traversed during rush hour and the train tracks, far from being abandoned,

serve as a municipal light rail line. None of these things matter for the artist who exposes the underlying bleakness of the place *sans* pedestrians and *sans* commuters. The R Street paintings neither reflect a social conscience nor do they attempt to persuade or educate the viewer about urban life; they are about mood, setting, and formal relationships.

One recurring motif in this series of paintings is the former Hollywood Furniture Store building by the Sacramento Municipal Utilities District (SMUD) station at the intersection of Stockton Boulevard and the train tracks. With its bland, flat, white-washed stucco façade and parabola windows, it is the perfect receptacle for mirroring transitory light effects ranging from the white heat of midday to the shadowy coolness of early evening. The building's blank features serve equally as a foil for the fretwork of poles and power lines, train tracks, and signage that fragment the picture into myriad geometrical forms. Likewise, the quiet lyricism of a painting like *34th and R with Crows* (page75) achieves its *gravitas* not on account of the slightly ominous presence of crows, but through the illogical convergence of streets and rail tracks, odd angles, and accidental formal relationships of man-made objects at twilight.

In the Light Rail series of paintings, the cityscape slips almost entirely from view, giving way to the electrical poles and wires that dominate the skyline. Fred feels these geometrically constructed paintings resemble Richard Diebenkorn's Ocean

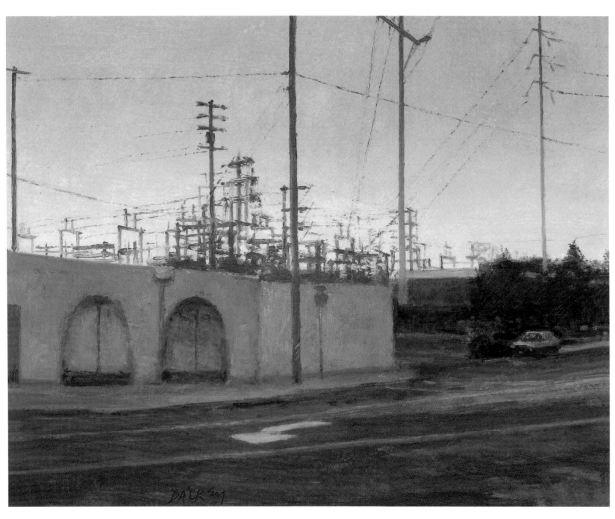

SMUD Substation, 34th & Stockton, 1990
oil on board
11 " x 14"
Collection of Fred and Victoria Dalkey

Park series in that the subject serves less as a central motif than as a point of departure, an excuse for inventing pictures. Unlike the Ocean Park paintings, the Light Rail series is more dependent on a sense of spatial recession to draw the viewer into the pictorial space. A painting like *Red Sky at Morning* (page 87) also achieves much of its power from the use of gradations of color from brilliant oranges and reds in the sky to deep blues and purples in the shadows. Viewers familiar with the setting may be moved by the artist's poetic transcription of an industrial wasteland into a thing of beauty, but more than anything the R Street and Light Rail series represents his intimate musings on the strangeness of painting.

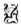

The site of much of Fred's output during the 1990s is his studio one flight up in a dilapidated and unheated structure in downtown Sacramento. The north-facing bay window in the front studio looks out on a cluster of high rises and pawnshops. Canary Island palms across the street filter the bright summer sunlight and provide shade for pedestrians and resident transients alike. Inside, the linear grid of the floorboards provides a framework for the placement of a daybed, an easel, and canvasses. A paint-splattered table plays host to an informal still life including a ball of string and a bottle of English turpentine while an unstrung violin hangs near the window. It is a good place for an artist to ruminate or for a model to catch a cold. A second space down the hall contains a press and more artwork resting against graffiti-festooned walls.

The process of beginning a new work is a painful one with which most artists are familiar and for which each resorts to his or her own self-disciplinary method in summoning the Muse. For Fred, this involves intense concentration and sublimation to his immediate surroundings. In a heightened state of awareness, Fred feels that "nature hums" with the "sound of air." He observes the tangibility of light and the way it inhabits and defines the properties it abuts. Light takes on shape and volume through color and in Fred's vision air or negative space is charged with "sound color," giving the space surrounding objects its own vitality and "spiritual singularity." The figures and still-life objects themselves take shape in a kind of "light envelope" that forms the structural bridge between object and atmosphere. In the intensity of the artist's imaginative focus, the objects take on "magical properties that nature has itself."

The air is certainly thick in a painting like *The White Studio* (opposite) that, as a forerunner of his studio series, Fred quite properly calls an *Annunciation*. Executed in 1992 prior to taking up residence in his current studio, the painting features a virgin canvas on an easel in a white room. The daybed and canvasses resting against the walls are also white and untouched. The easel stands near an open door and transom to the right while further away on the opposite side of the room a window provides a source of light. With its nuanced gradations of light and shadow, subtle incorporation of color, and unseen presence of

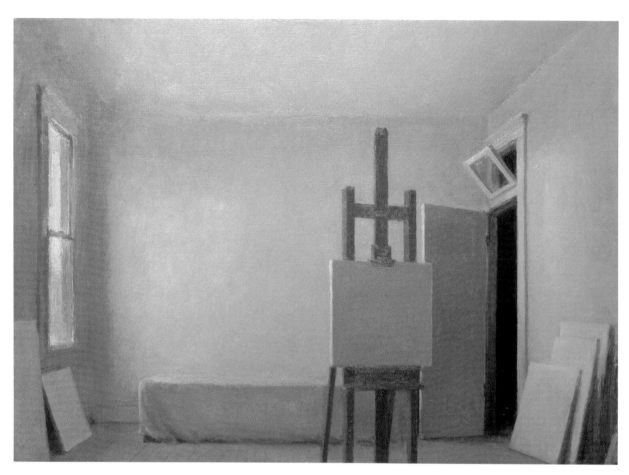

Annunciation: the White Studio, 1991
oil on linen
20" x 28"
Collection of Elizabeth and Mason Phelps

the artist, the painting silently evokes the place and moments preceding the act of creation. Apart from the obvious religious symbolism, *The White Studio* is a declaration of the artist's openness and receptivity upon arrival in the studio to the guiding spirit of light and atmosphere. Fred likens his working method to improvisation in twelve bar blues, a structured and repetitive form where the flexibility of the musical line is the outgrowth of immediate sensation and feeling. What we may initially perceive as void becomes a universe pulsating with light, sound, and color, life at the moment of its generation set in a space that is the very opposite of empty.

Although *The White Studio* is on the surface a realist painting, it has in common with Surrealism an element of the enigmatic and the mysterious. A painting like René Magritte's *Les Valeurs personelles* gives ordinary utilitarian objects (a comb, a glass, and a shaving brush) monumental importance by allowing them to dominate the confines of a small room.[9] Magritte further does away with natural light and brings the outdoors inside by depicting a blue sky and cumulus clouds on the wall. As such, the visible world turned on its head becomes a gateway to the realities of the unconscious mind. *The White Studio*, by contrast, has at its center a primed but untouched canvas of conventional proportions in a naturally lit setting. Nonetheless, the uninflected details of the painting serve as a means of entry to the mindset and personal values of the artist who remains an invisible but potent presence.

All of Fred's subsequent studio paintings stem from this harmonic convergence of the real and the surreal, the ostensible subject of a painting and its symbolic narrative as found in *The White Studio*. His paintings of *Emily Seated on a Table* (page 76) and *Emily in Room A-11* (a classroom at City College) have, at their center, the realistic depiction of a model in a defined space. In both cases, however, the placement of the model in mid-distance and the emphasis on flat surfaces and simple geometric forms deny intimacy with the subject and shift one's interest towards the deliberate but understated formal values. As he grows into and develops the theme of the artist's model in the studio, Fred becomes increasingly preoccupied with light and atmosphere and the subjective feelings they invoke over any specific content. In *Tabitha Covering her Face* (opposite), for example, the outlines of the room have dissolved entirely into blocky, heavy masses of light with the central figure denying the viewer access to her individuality by covering her face. The way the light models the figure around the waist further destabilizes her as a three-dimensional object and absorbs her into the enveloping atmosphere. And in *Stacey with Weeping Green (Kore)* (page 83), the artist reduces all sense of volume and situates the figure in a "light chamber" shot through with non-naturalistic shades of green.

The later works in this series appear initially to be further removed from immediate experience, but this is not Fred's intention. Paintings like *Tabitha Covering her Face* or *Stacey with Weeping Green*

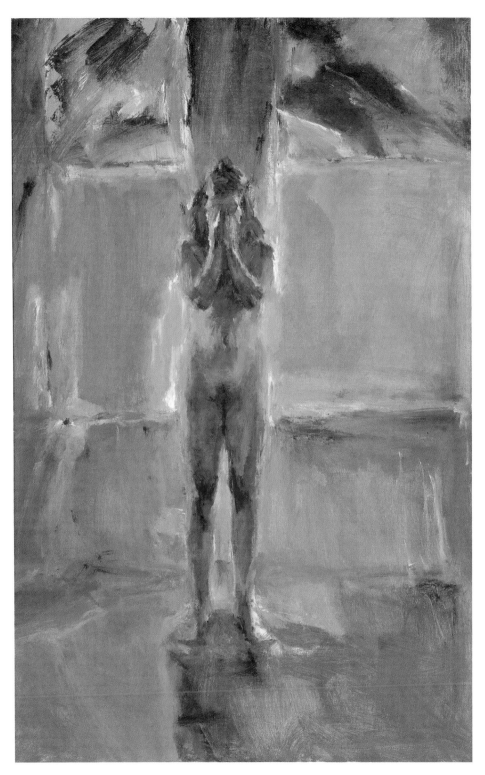

Tabitha Covering Her Face, 1994
oil on linen
44" x 28"
Lent by the artist

(Kore) are executed alla prima as records of the artist's visual perception. While local color has been subjugated to backlighting and overriding atmospheric effects, Fred considers these to be among his most realistic paintings as they are done on the spot without much retouching or afterthought. The emphasis on prismatic colors has the effect of stripping the paintings of all anecdote and giving volume and form to space. The human figure becomes a galvanizing force around which the bold, blotchy strokes of pigment are arranged, recording ocular sensation at the moment of experience in the manner of Seurat's *The Models*. In such paintings, the subject and the medium become indistinguishable.

The most monumental and light-adoring work from this series is the painting simply known as *Frieze* (opposite and page 79). *Frieze* is executed on four canvasses measuring in sum five by nearly eleven feet and each of the four canvasses depicts a single standing figure. Like most narrative friezes, the painting works best when examined from left to right. The figure at farthest left is cast in deep shadow and its pose is obscure, a symbolic begin-

ning as yet only half perceived. The two central figures stand facing front with arms hanging to the side indicating openness in the former and lightly crossed in a gesture of modesty in the latter. The figure at far right walks away in near profile either unaware of or unaffected by the appraising gaze of the artist and of the viewer. Despite the expressionistic handling of the paint, the work is remarkable for its restraint and its adherence to classical formal values, subtle interplay between color and surface, and rhythmic linear activity.

It is tempting to view *Frieze* as a kind of life cycle in the manner of Paul Gauguin's *Where Do We Come From? Who Are We? Where Are We Going?* or Edvard Munch's *Dance of Life* where youth, maturity, and old age appear in fatal and inevitable succession. But *Frieze* is neither as programmatic nor as specific in its conception of the passage of time. Although the painting depicts the same model in four different attitudes, the actions take place simultaneously within a unified space and under a single light source. The conundrum of four activities being performed at once by the same person is one that defies conventional logic and, in

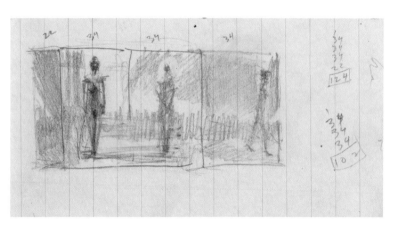

Frieze (Thumbnail Sketch), 1994
graphite on paper
4" x 8"
Collection of Fred and Victoria Dalkey

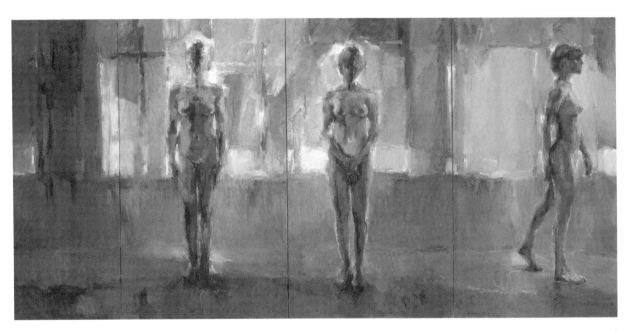

Frieze, 1994
oil on linen, four panels
60 1/4" x 124"
Collection of Steven and Nancy Schwab

effect, transcends the limitations of time and space. In showing us four overlapping actions in a continuum, Fred reminds us of the beauty and uniqueness of a moment in a succession of moments made all the more precious by the knowledge that they are soon gone and lost forever.

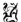

Fred finds wells of inspiration for his art in listening to music. This afternoon it is the Sibelius Violin Concerto that fills the rooms of his Sacramento home, mixing with the scents of *pu'er* tea and ginger. He is playing a Jascha Heifetz recording on vinyl complete with occasional wobbles in the sound backed by a steady hiss of fireplace crackling. Heifetz offers a somewhat crudely articulated but brilliant rendition of the Sibelius concerto that Fred compares to "the sound of air" or "aural space" in his paintings and drawings. The recording reminds him of his studies with Abe Nussbaum and of his never-achieved ambition to play the violin, "like Matisse standing at his window." For contrast, he then plays Bob Dylan's "*Never Say Goodbye*," a source of inspiration for his work *Persephone in Minnesota*.

He talks about high culture and popular culture, the dichotomy between traditional and "cutting edge" art, the range of media in which he has worked, and the major influences on his life and career. He insists that his goal as an artist is to achieve a "spirituality of the mundane" through the "wholeness of the image." I ask him that if he could characterize his work in musical terms would he choose Dylan or Sibelius? Unhesitatingly, he responds "both." Then, after a pause, he adds with emphasis, "Mostly Sibelius."

Peter J. Flagg holds a Ph.D. in art history from Princeton University and is the curator of over forty exhibitions. Formerly assistant professor at Connecticut College, he is currently Director of European Art at Montgomery Gallery in San Francisco.

End Notes

1. I am grateful to Victoria Dalkey for providing biographical information about the artist. All quotations unless otherwise indicated are the words of the artist.
2. Rembrandt van Rijn, *A Jewish Rabbi*, National Gallery, London, oil on canvas, 1657.
3. *French Paintings from French Museums*, XVII-XVIII Centuries. Introduction by Michel Laclotte. E.B. Crocker Art Gallery, Sacramento, 19 January - 25 February 1968.
4. *Five Hundred Self-Portraits. From Antique Times to the Present Day in Sculpture, Painting, Drawing, and Engraving.* Chosen, edited, and introduced by Ludwig Goldscheider. Translated by J. Byam Shaw. Phaidon, Vienna, 1937; London, George Allen & Unwin, 1937.
5. Dalkey's son, Emile, found the 1980 *Self-Portrait* so disturbing that he once removed the painting from the wall before a party so that he and his guests could enjoy themselves without the stern look of parental disapproval overhead.
6. Remdrandt van Rijn, *Faust*, c.1652, B270.
7. Kenneth Baker, "Dalkey Drawings," in *San Francisco Chronicle*, May 6 1997, E4.
8. J. Didion, "Notes from a Native Daughter," in *Slouching Towards Bethlehem*, New York, Farrar, Strauss and Giroux, 2000, 172.
9. René Magritte, *Les Valeurs personelles (Personal Values)*, San Francisco Museum of Modern Art, oil on canvas, 1952.

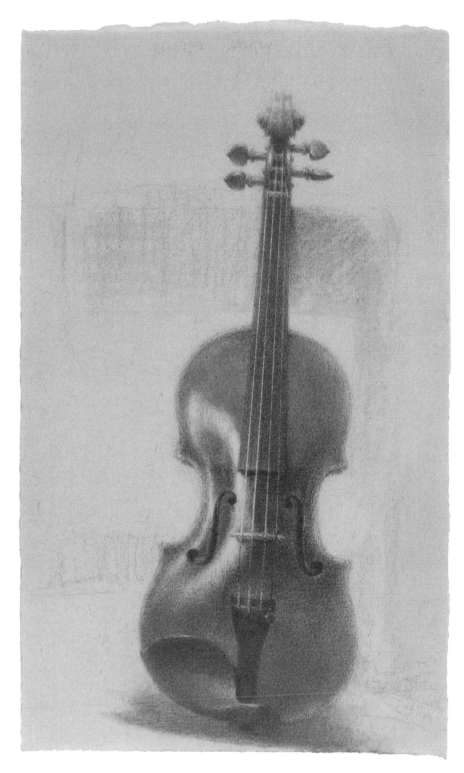

Violin, 1992
sanguine Conté on paper
10 3/4" x 6 1/2"
Collection of Penny Harding and Bill Mahan

THE ILLUMINATED IMAGES OF FRED DALKEY

CHRIS DAUBERT

Summers are hot in the Valley. When the Delta breezes are not blowing, the air is heavy and still with the collected dust and pollen from the thousands of acres of farmland surrounding Sacramento. The streets of the city, arched over by full-grown trees planted in the 1920s and 30s and now full of cars and busses, add to the fragrance and density of air. And perhaps, most of all, the confluence of the American and Sacramento Rivers, which drain the Central Valley of California, is only a mile and a half from downtown, and defines the city. A river city, Sacramento is a hub of trade and shipping, run through with water and surrounded by the moist light of the rivers.

Fred Dalkey, who was born and raised in Sacramento, has been making pictures in the urban and riparian environments defined by these rivers since he was a child. Being surrounded by the city with its particular light had a profound impact on the drawings and paintings which he would create over the next forty-five years. The light, seemingly hanging in the air of a summer afternoon, would become a character, permeating not only the views of Sacramento, but his work as a whole.

It seems natural that Fred Dalkey would be drawn to paint images of the water which surrounds and identifies his city. The river paintings – which

include images of rivers, lakes, ponds and sloughs – were a subject of his work for only a few years in the late 1980s and early 90s, and yet they constituted a focus of his earlier investigations into the tangibility of light and atmosphere. These paintings are traditional in the sense that they accept and understand the guiding features which have driven other great river-school paintings, specifically the alchemy which turns paint into air. They possess the infused atmosphere which unifies air and water and carries the light into the deepest recesses of the image. While being direct in their sense of observed location, they are able to convey the atmospheric diffusion which transforms individual forms into soft grouped masses as the image recedes into the distance. And this light (it is no longer paint) carries the color throughout the landscape. The cool morning air of *Land Park Pond* (page 29) believably carries the lavender sky down to the surface of the water as it fills in the distance between the viewer and the shadowed trees of the far shore; the sultry afternoon of *Bannon Slough* (opposite), with golden light infusing the scene makes even the high-tension power lines in the distance part of the accepted feeling of a specific time and place.

These paintings, so specific to Fred Dalkey's work and to Sacramento, were completed during

Bannon Slough, 1990
oil on linen
20" x 16"
Collection of Karen Searson

the heyday of the other Sacramento River painters, Wayne Thiebaud and Gregory Kondos, whose crystalline vision and acidly cheerful coloration became a dominant part of the American artistic landscape. Dalkey, who is a longtime friend and painting companion of Thiebaud's, and who was a student of Kondos was, of course, fully aware of the achievements of his older contemporaries.

His decision to continue this more traditional field of investigation is consistent with his childhood training with Abe Nussbaum. It also reflects his well-known single-mindedness, and his embeddedness in the sensual light, color and atmospheric texture of the river city.

One of the precedents for Dalkey's attention to the observational renderings of the river scenes with their charged atmosphere can be found in a previous body of work completed several years prior to the landscapes. In these pastel and mixed-media works on paper, light itself is an elemental object. In *Mumbling*, (opposite) a central figure is surrounded by a collection of runes, all of which are glowing with a particulate incandescent aura. In this piece, the coarse application of material at

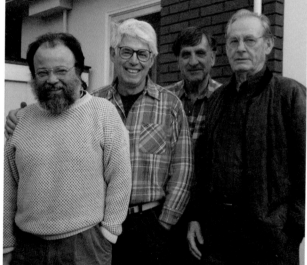

Fred Dalkey with Wolf Kahn, Gregory Kondos and Wayne Thiebaud at Kondos residence in 1993

once shows the technique used in its making and simultaneously creates the illusion of light suspended in atmosphere.

These synthetic works, completed in the early 1980s, demonstrated the intersection of two ongoing fields of Dalkey's investigation: the portrayal of the human figure, and the developing concept of light as an activating force, an energized, objectified entity. Working independently of the California "Light and Space" movement, Dalkey nonetheless explored in these works many of the same fundamental qualities of light which were the earmarks of those artists usually creating site-specific installations. In works such as *Mumbling* and *KA* (page 62), he specifically addressed the optical experience of seeing light. Light in these works is an object, sometimes particulate, and always identified as a source of energy.

On one level, the paintings of the urban landscape bring to mind Monet's Cathedral at Rouen series in their intensified attention paid to the subtle changes brought by the change of time of day, the quality of the air, and the subtle play of humidity and temperature. In the painting, *Red*

TIME LAYERS: THE DRAWINGS OF FRED DALKEY

Julia Couzens

Old, high-ceilinged City College classroom on a winter night, twenty-six years ago. I stand struggling with dumb fists, seeking a way to paint the bowl. The instructor, telepathic to student pain, circles closer in *sotto voce* to say, "When you can't find the right color, use the wrong color." And so began my education from a master.

Fred Dalkey, like the workings of the creative process, taught circuitously. From him, I learned that process leads the artist. The mind is the last to see what our eyes already know as we grow into our work.

Fred would often work with us in the dusty classrooms, his worn leather satchel spawning bamboo pens, quill pens, inks, sanguine, and rich, buttery papers torn into small, exquisite sheets. His drawings set out to dry were arrayed like Tarot cards on the desktop – each sheet a quick study and a lesson in economy, gesture as a quality of touch, and emotion held in firm control.

Dalkey's drawings possess a particular stillness, creating a space between tension and silent calm. Chalk red stillness outside of time. The act of perception and the penetrating focus of his eye measures finely calibrated increments of space. Focusing and re-focusing, Dalkey speaks of "seeing in layers, time layers." From the first quick glance to the second, third, and fourth

comprehension of the model, his dense act of observation is articulated with, and matched by, each stroke of chalk. Eye and hand are one.

A Dalkey drawing is a personal investigation into the nature of seeing. As is often the case with many artists, his approach to drawing is the adhesive that holds together his searching, multi-faceted work. And Conté, a semi-hard chalk of fine texture, is the glue. The drawings reveal his unique feeling for this dry medium and his sensitivity to its intrinsic beauty and expressive range. Possessing a slightly oily binder, Conté is not as easily erased as charcoal. It is a medium that requires experience and practice to render the rich and resonant contrasts in value that are among the hallmarks of Dalkey's drawing.

His obvious pleasure in craft and high standards of production are important components of his work. He selects paper with careful attention to its color and grain. The pressure of chalk to grain translates a ball of string, a top hat, a model's dirty feet into complex surface patterns with no directional strokes. The somewhat impersonal, cerebral and less visceral surface simplifies elements, separating art from life into an almost abstract, monumental form. "*Ball of String*" (opposite) could be Monet's haystack. The drama and monumentality of this prosaic image shift the

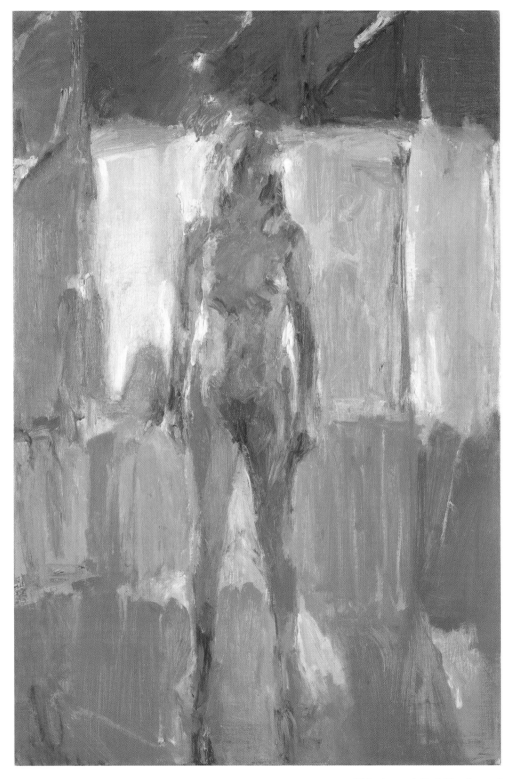

Tabitha with Red Hand, 1994
oil on linen
48" x 32"
Lent by the artist

Skylight (page 77), the light cascading from above has a specific weight, a force falling like water on to the model. In other paintings, the light carries spectral color which is not released until it interacts with the figure. Saturated violet turns into brilliant yellow and red in *Tabitha with Red Hand* (opposite), and the almost religious composition in *Tabitha Covering Her Face* (page 35) is further enhanced by the transformation of paint into pure light as it surrounds the figure.

This branching investigative development of Fred Dalkey's work over the years has produced an exemplary body of drawings and paintings whose variety is underlayed by an unyielding intensity of approach and marked by the complementary aspects of its own luminosity where the air carries the light and the color creates the air.

Chris Daubert is an artist and Professor of Art at Sacramento City College

It is in the Conté drawings where the saturation of air by light is the most tangible. In these drawings, the entire surface of the paper becomes charged with the specific quality of an atmospheric light, creating a play of light not across the picture plane, but through the rendered air. The hazy atmosphere and the figures emerging from it are created by the delicate interplay of the Conté and the surface of the paper. This texture informs both air and substance and subtle changes of color are created by the paper's compression during the act of drawing.

The images are manifested both by what is drawn and also what is left out. Pooled shadows create the forms shielded from the light, while the figures themselves are created by those negative areas pulled out of the background and exposed to the illumination. In *Julie Rising* (above) and *Kristin with Chair Leg* (page 103) the figures seem to be rendered by the light itself, which falls on and in front of them as subtle changes of value across the pictures create both the direction of the light and the effect of light suspended in air.

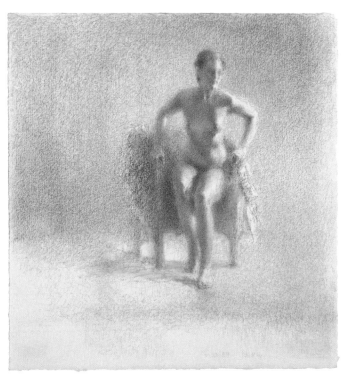

Julie Rising, 1994
sanguine Conté on paper
9 1/4" x 8 3/4"
Collection of Russ Solomon and Elizabeth Galindo

An earlier drawing, *Life Class* (page 91) which is dominated by the sheer force of falling light on the figure, foreshadows the latest paintings. From the mid-1990s on, in a series of expressionistic figure paintings, light is transformed into concrete slabs of color. In these paintings the physicality of gesture and emotion reflect a new synthesis of paint and light. The figures, although identified as specific individuals, are not portraits as much as mute archetypal figures, standing and trying to hold their own among almost glacial blocks of colored energy.

In these works the thickness and immediacy of Dalkey's painting is in stark contrast to the carefully modulated surface of the drawings but both address light in similar terms of physical form and rendered energy. In *Emily Under a*

45

Sky at Morning (page 87) the beginning of a hot August day in Sacramento is felt as well as seen. This red sky, familiar to urban dwellers more than to sailors, with its accumulated days of human activity without even a slight cleansing breeze is portrayed coloring the air and carrying the light down to the ground.

These closely observed renderings are inherently situational, being of both time and place. They focus predominantly on dawn or dusk, when the indirect light of the sun is filtered through the laden air. The color and light of sunrise in *34th and R with Crows* (page 75) radiates up and through the painting, carrying the viewer into the sky following the flight of the birds, while in *27th and P (8 p.m. 1 August)* (page 71) the eye is pulled down by the darkening sky and carried into the distance by the enforced perspective of the street.

The beginning of this ongoing series of urban landscapes coincided with the water scenes, but there is a significant difference between the two bodies of work. In most of the water scenes, as if to underscore the importance of water and its qualities of reflection and atmospheric density, the bottom two-thirds of the painting's surface is dedicated to the water itself, while the images of streets are dominated by the sky and the effects of the atmosphere. This allows Dalkey to completely investigate what has become a dominant factor in his paintings: charged air carrying light that is transformed by the colors suspended in it. As opposed to the immaculate air and direct color in

the paintings of buildings by Edward Hopper, every facet of these images is filtered through color. While the use of atmospheric effects and palette might suggest an Impressionist approach, these paintings maintain remarkable clarity of surface and direct application of paint.

A pivotal painting bridging the landscapes and the studio still lifes and figurative works is *Annunciation: The White Studio* (page 9), a Vermeer-like study of an apparently empty studio with light streaming in from the window on the left wall. Within the context of Dalkey's oeuvre, the studio is not empty at all, but is filled with light. Every surface within the room reflects, absorbs, diffracts, or diffuses the illumination. It is interesting to take note of the surfaces of the "blank" canvases arrayed around the room. Every one of these surfaces is a painting unto itself, each recording a different source and intensity of light. If *The White Studio* were diagrammed according to the directions and reflections that the light takes from its entrance through the window to the eventual darkness on the opposite side of the room, it would be a maze of intersecting lines and arrows. With this is the gradual diminution of the intensity of the light as it is reflected first by the back wall and the wall opposite the window, then by the small canvas below the window, and finally by the canvas facing the viewer. Beyond the observed qualities of brightness is Dalkey's knowledge, gained from years of working with light as the ostensible subject of his paintings. For him, that light is energy, an activating force much more than a passive source of illumination.

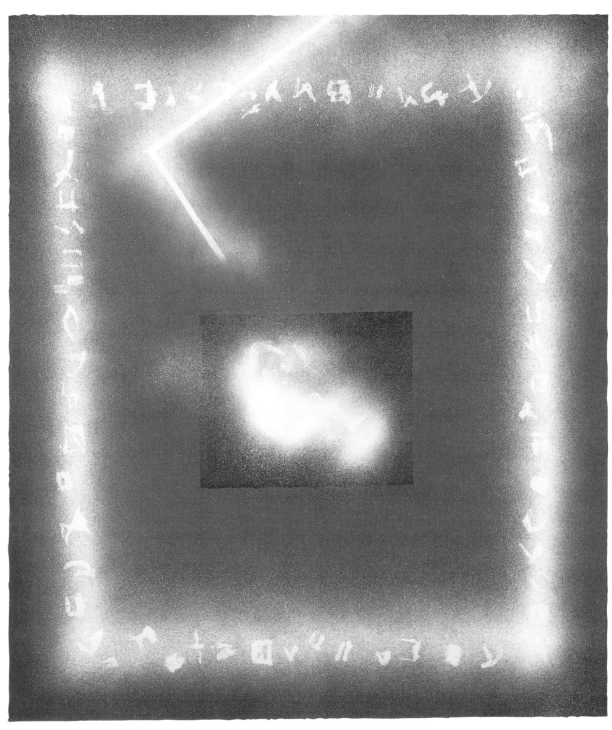

Mumbling, 1983
pastel with mixed media on paper
26 3/4" x 23 1/2"
Lent by the artist

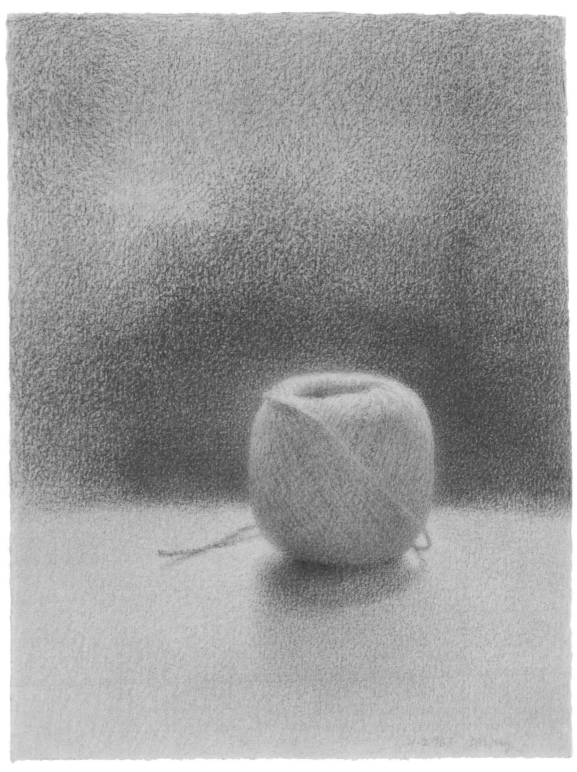

Ball of String, 1996
sanguine Conté on paper
10 3/4" x 8 1/4"
Collection of Fred and Victoria Dalkey

drawing's meaning; the drawing becomes a portrait, with implications of a richer psychological dimension.

"*Stacey with Morandi Still Life*" (page 26) and "*The Old Floating Hat Trick*" (opposite) are two drawings that emphasize Dalkey's concern for stasis and tension between subject and form, figure and ground. Organizing space through scale and placement of image, through a lens of light and tone, he renders the artifice of art breathtakingly real – Dalkey magic. We enter into his zone of interior light emanating from the chalky surface, pushed and pulled by the rhythms of his touch, to encounter the thigh, the curving saddle of the back, the nipple, and the chair leg beyond.

Unlike the gee-whiz intentions and easy seductions of trompe l'oeil, Dalkey's work moves his vision outside of time and place, suspended in a silent present. The drawings do not refer to their own making, as the events of the drawing process give way to a heightened awareness of the mutability and plasticity of space. In such a work as the portrait "*Jian Wang*" (page 98), the nervous flurry of marks compromises the form's edge. The subject's head is woven into the background and the background moves forward to our touch, as the drawing conceptualizes space in the act of duplicating the artist's probing vision.

Dalkey's drawings are the work of an artist fully in command. Their abiding strength has to do with his manner of seeing and the suppleness of his pictorial space articulated by a breathing light. It is work drawn from the integrity of lived experience and a focused intensity shaped by his relentless need to question the way things look.

Julia Couzens is an artist living and working in Clarksburg, California

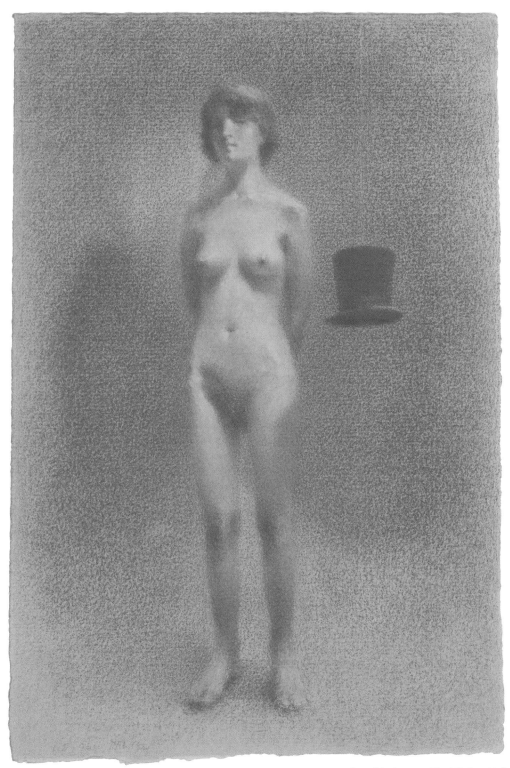

The Old Floating Hat Trick, 1996
sanguine Conté on paper
11 1/16" x 7 9/16"
Collection of Paul LeBaron Thiebaud

What the Object Can Do

Michaele LeCompte

For almost 30 years I have held in my custodial care, a small drawing of a monkey behind a wire cage. This was the first artwork I had ever purchased, and I bought it at a time when my new husband and I had very little money. We were both working unrewarding jobs at the time and going to school. Looking back, I'm trying to reconnect with the young woman who had the confidence and wisdom to know what money really buys.

As I walked to Mr. Dalkey's house with the $65.00 in my pocket, a clear thought came to me: Mr. Dalkey would spend the money on something needed, perhaps, but not remembered, while I would have this beautiful drawing for the rest of my life.

The years have passed swiftly, and I am still alive to this image and it is still alive to me. This object opened worlds to me. At the time I didn't know I had become a "collector" – I don't even know if I knew the meaning of the word. I certainly never imagined that somebody like me could ever own anything so fine.

But somehow I sensed that objects stand in for ideas, and ideas are linked to a kind of wordless knowing that goes far beyond the object itself. This small drawing is like a meditation, and when I look at it, I feel a deep stillness that lets me see it again, as if for the first time. This is a tremendous gift.

I'm sure that I didn't know these things at the time I gave in to my desire to have this lovely drawing, but these are some of the things I have come to understand about objects.

Thank you Fred.

Michaele LeCompte is a collector, and an artist, living in Sacramento

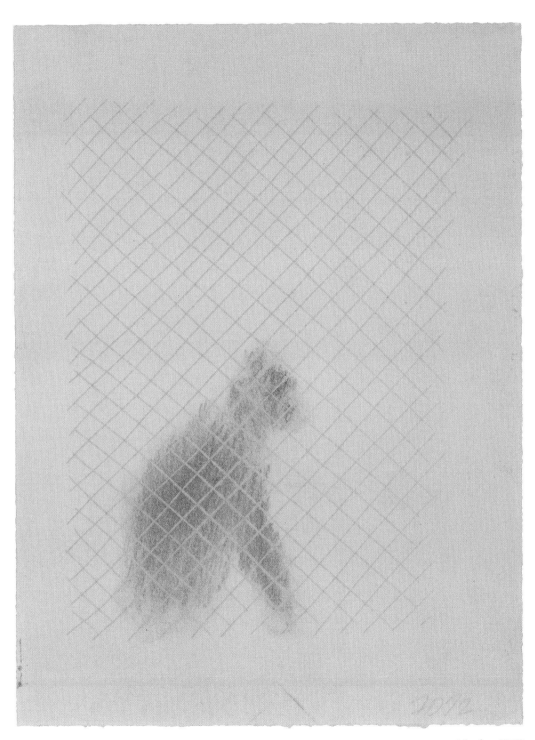

Monkey, 1972
silver point embossing with
sanguine and gray Conté
7 3/8" x 5 1/2"
Collection of Kendall and Michaele LeCompte

Emile, 1971
sanguine Conté on paper
5 1/4" x 4 7/8"
Collection of Fred and Victoria Dalkey

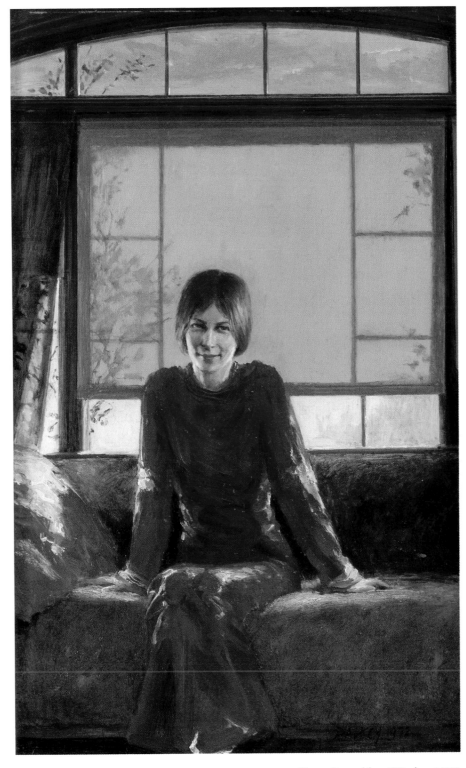

Karen Onstad by a Window, 1972
oil on masonite
16" x 10"
Collection of Karen Onstad-Corriveau

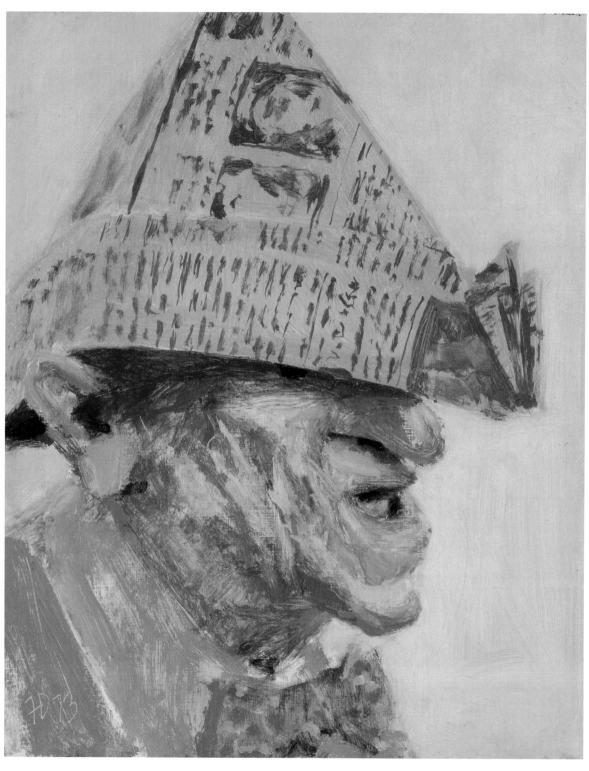

Convalescent Hospital Study (Man with Paper Hat), 1973
oil on panel
8" x 10"
Collection of Marilyn and Phil Isenberg

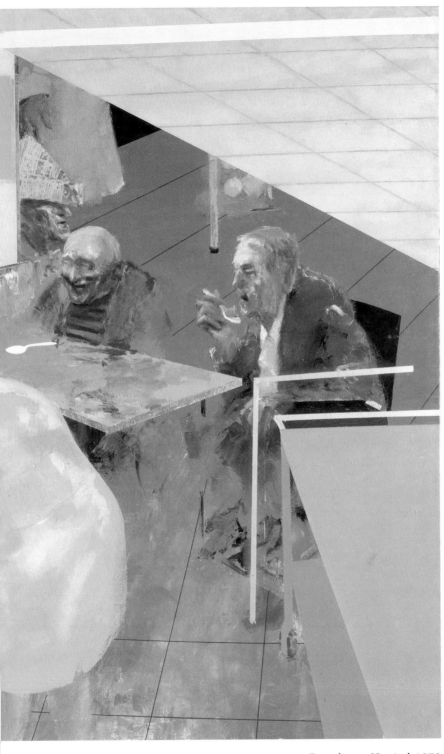

Convalescent Hospital, 1973
oil with mixed media on linen
66" x 87 7/8"
Collection of Crocker Art Museum
(Gift of the artist in memory of Hans Hohlwein)

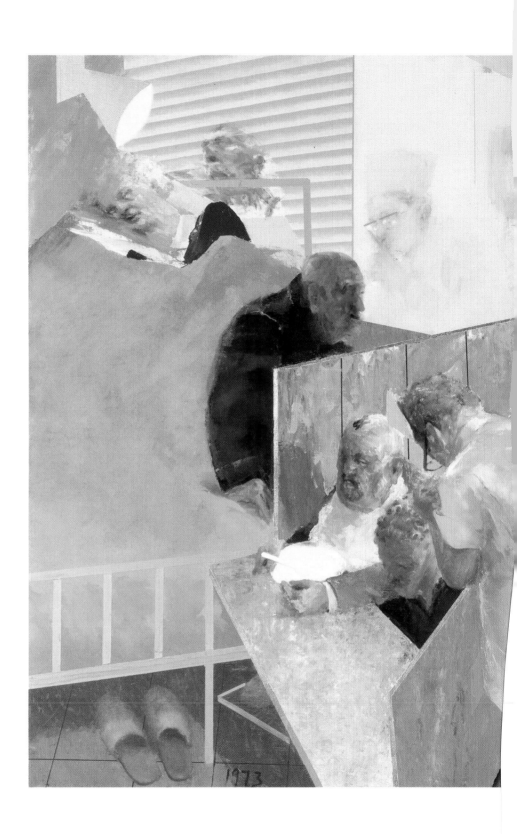

1973

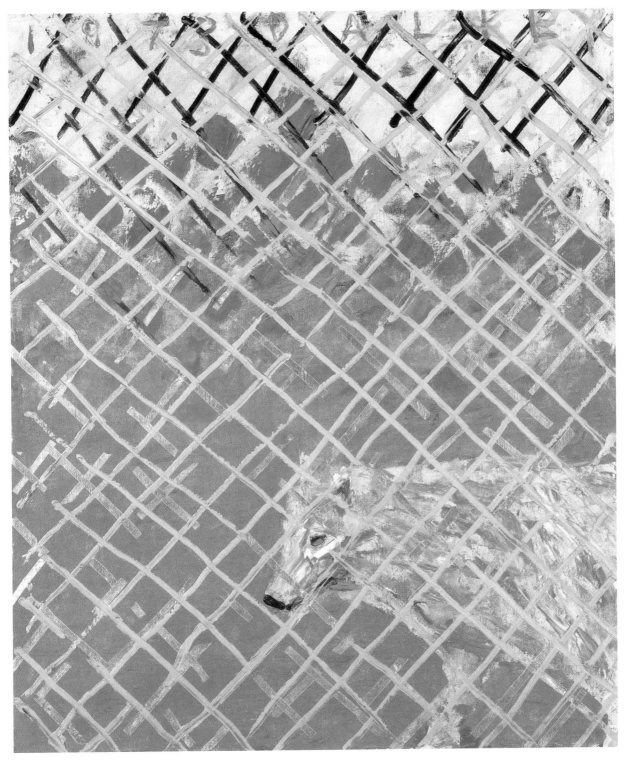

Timber Wolf, 1973
oil with mixed media on linen
32" x 27"
Lent by the artist

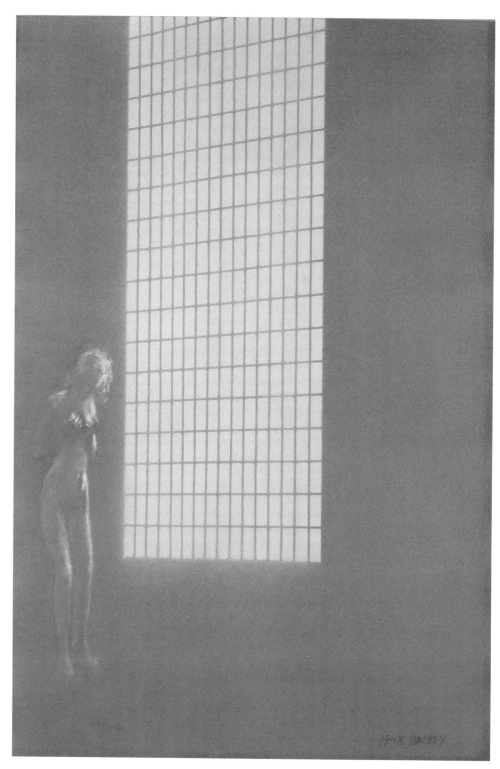

Faust's Study, 1978
pastel with mixed-media on paper
23 1/2" x 15 1/2"
Collection of Ada Brotman

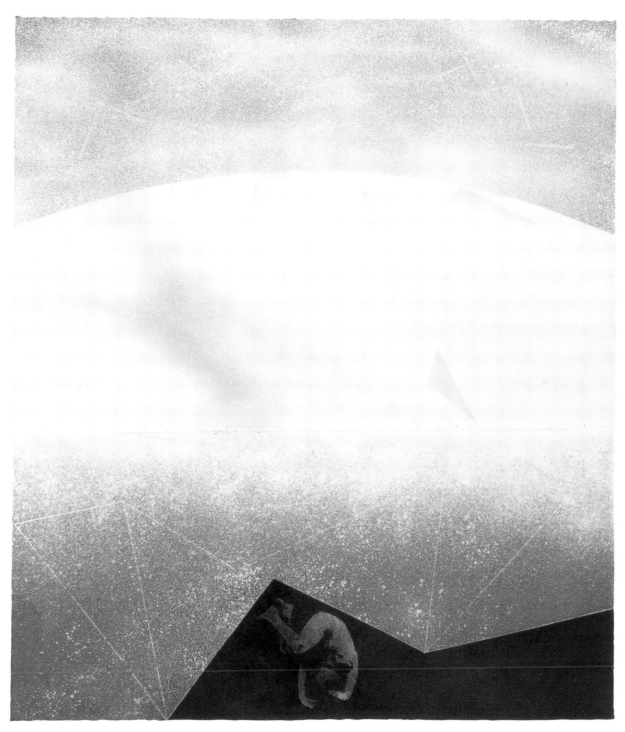

Persephone in Minnesota, 1981
pastel with mixed-media on paper
27" x 24"
Lent by the artist

KA, 1982
pastel with mixed-media on paper
29" x 23 3/4"
Lent by the artist

Avignon, 1983
pastel with mixed-media on paper
27" x 23 1/2"
Collection of Fred and Victoria Dalkey

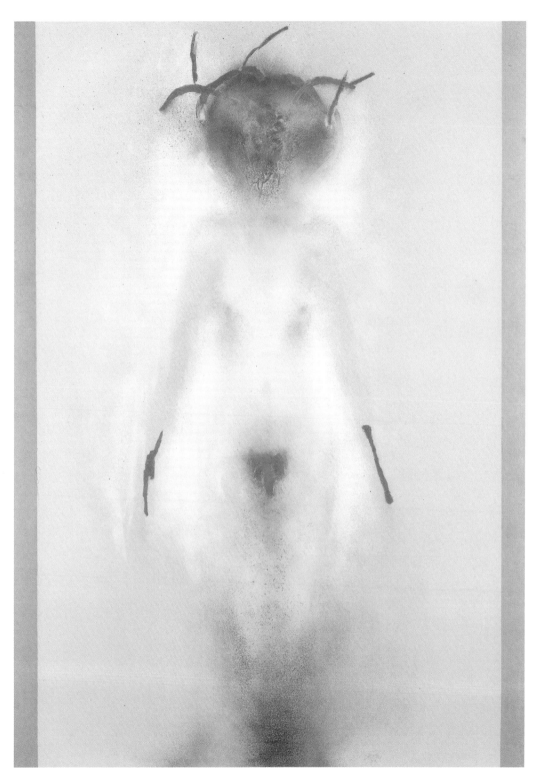

Passion, 1983
pastel with mixed-media on paper
33 1/2" x 23 3/4"
Collection of Fred and Victoria Dalkey

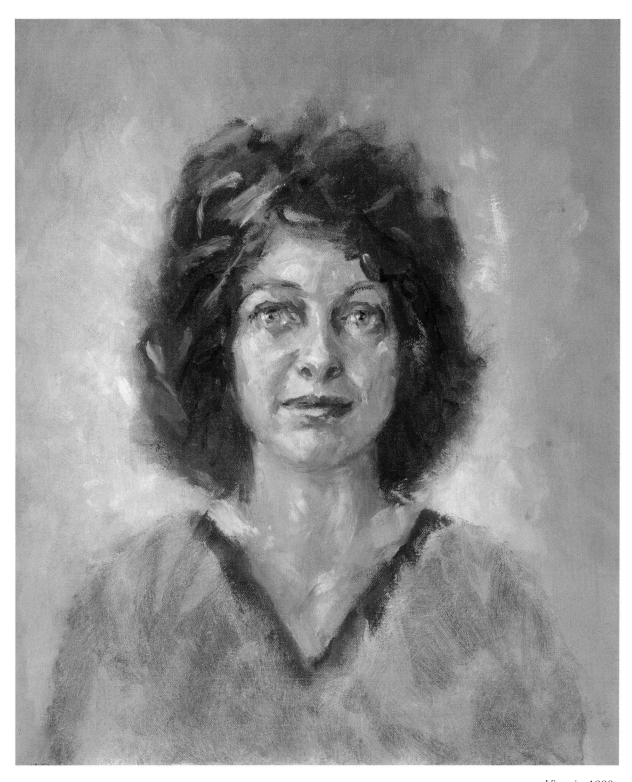

Victoria, 1980
oil on linen
24" x 20"
Collection of Fred and Victoria Dalkey

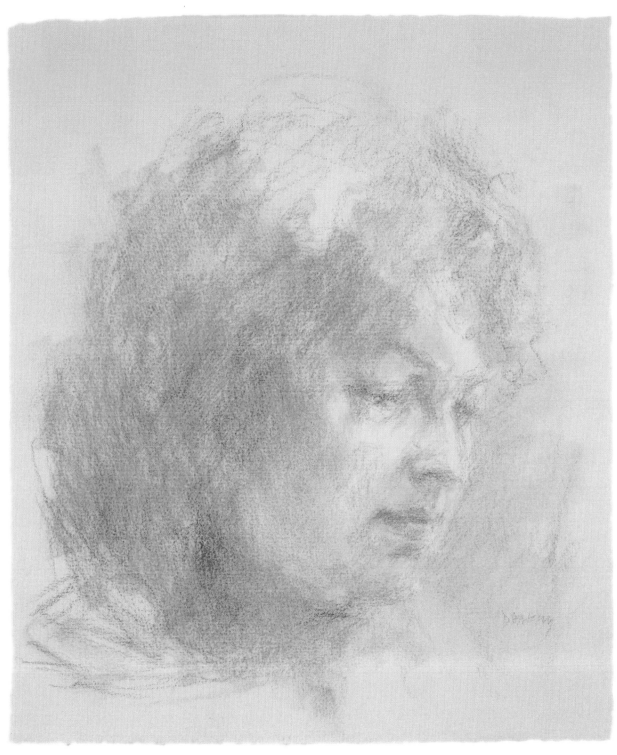

Victoria, n.d. (c.1985)
sanguine Conté on paper
9 1/2" x 8 1/8"
Collection of Fred and Victoria Dalkey

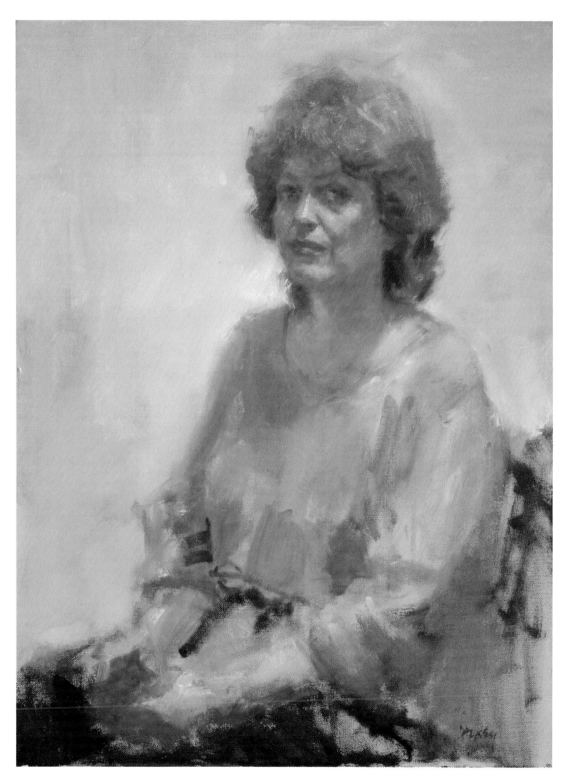

Victoria, 1992
oil on linen
24" x 18"
Collection of Fred and Victoria Dalkey

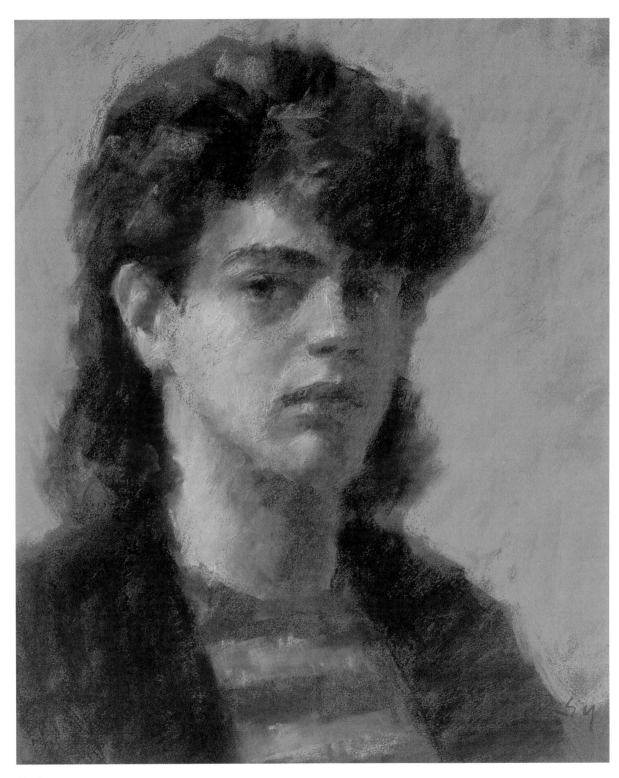

Emile, 1987
pastel on paper
18" x 15"
Collection of Fred and Victoria Dalkey

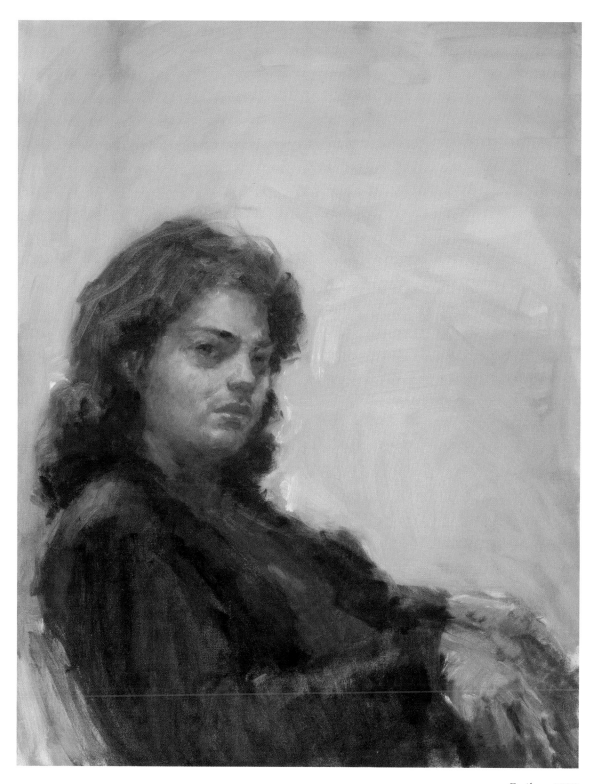

Emile, c. 1990
oil on linen
30" x 24"
Collection of Fred and Victoria Dalkey

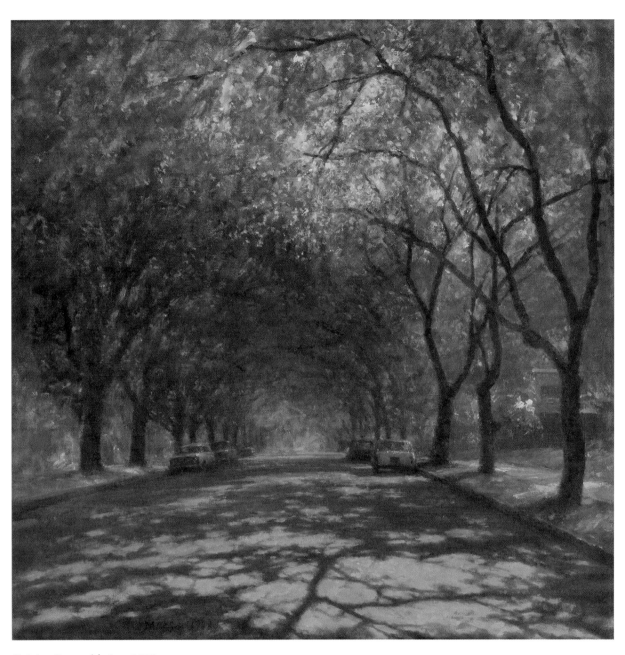

Driving Down 4th Ave., 1988
oil on linen
24" x 24"
Collection of Anne and Malcolm McHenry

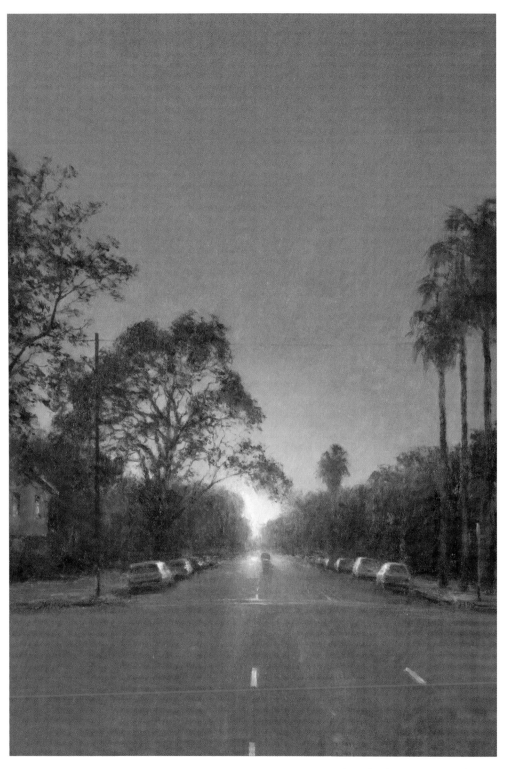

27th and P (8 p.m. 1 August), 1990
oil on linen
26" x 18"
Collection of Anne and Malcolm McHenry

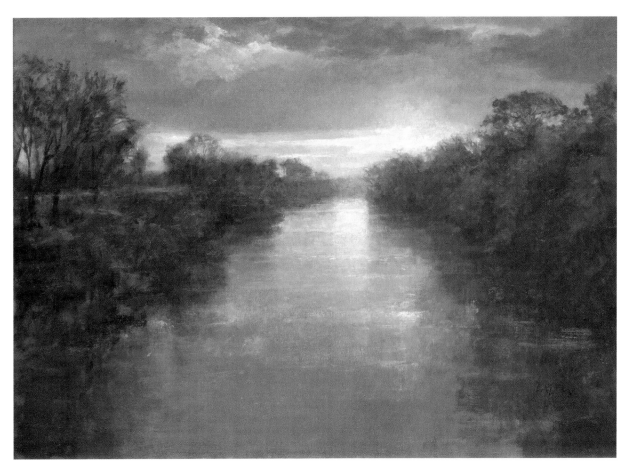

Elk Slough, 1990
oil on linen
24" x 34"
Collection of Bill and Sue Parker

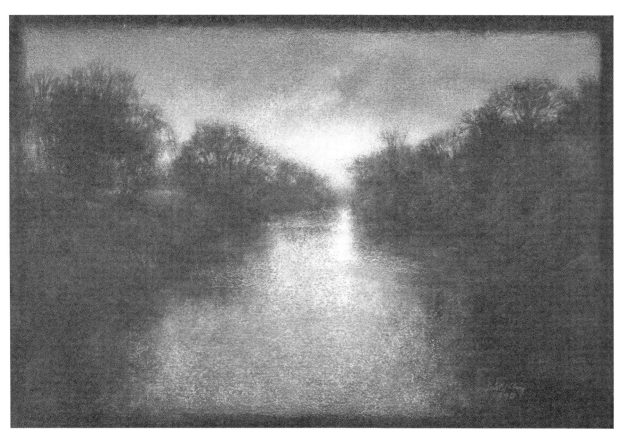

Elk Slough, 1990
white Conté on gray paper
7" x 10"
Collection of Kathryn Hohlwein

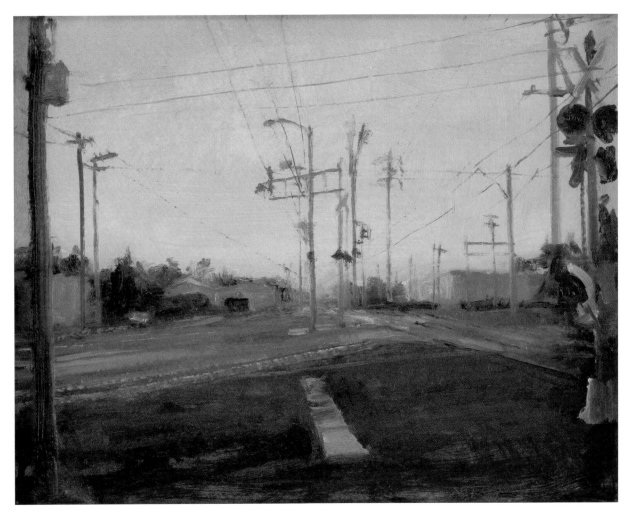

34th and R, Looking East, 1990
oil on board
11" x 14"
Collection of Betty Jean Thiebaud

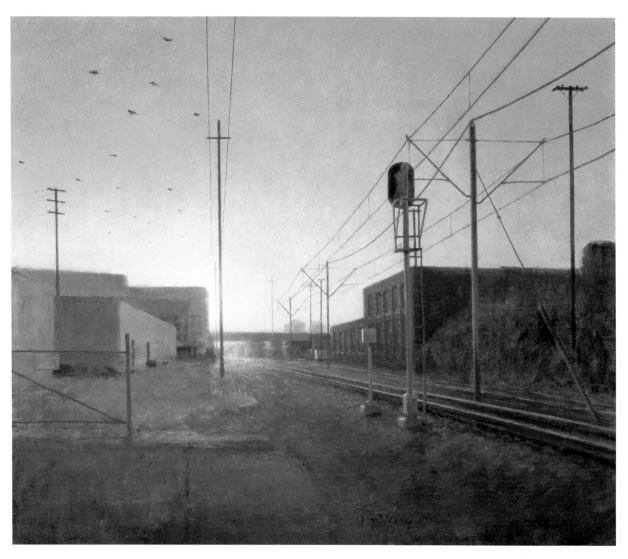

34th & R with Crows, 1990
oil on linen
22" x 26"
Collection of Frank LaPena

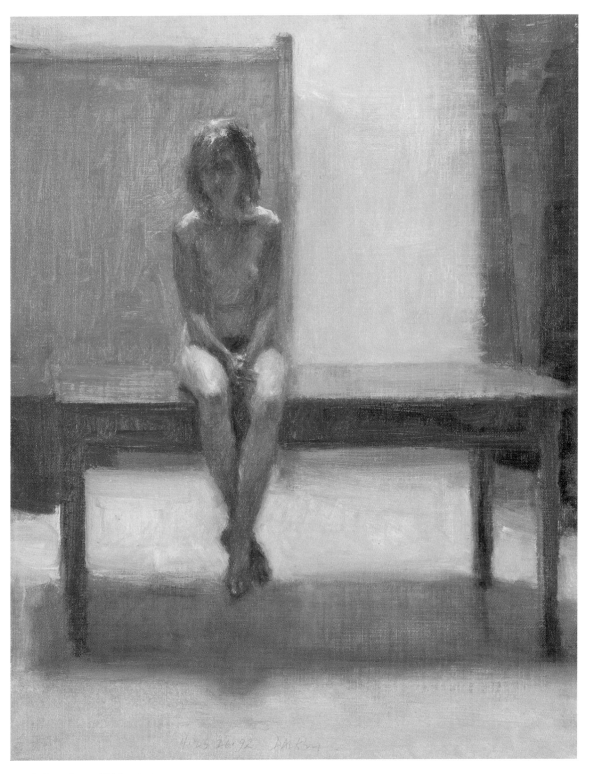

Emily Seated on a Table, 1992
oil on panel
14 1/2" x 11 1/2"
Collection of Laura and Scott Hill

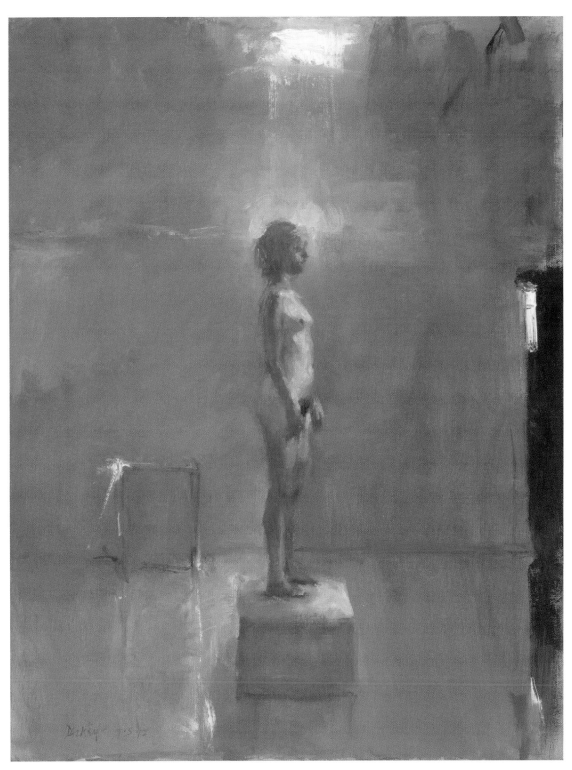

Emily Under a Skylight, 1992
oil on linen
26" x 20"
Collection of Jian and Bonnie Wang

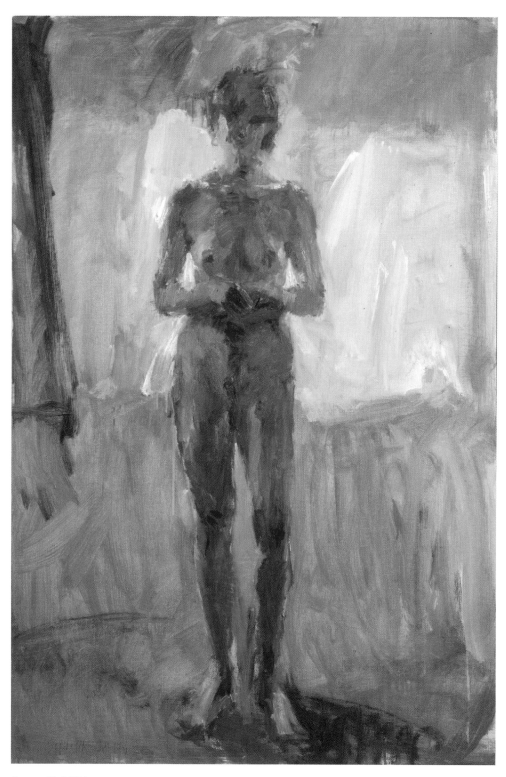

Stacey #1, 1994
oil on linen
48" x 32"
Collection of Carl and Ann Nielsen

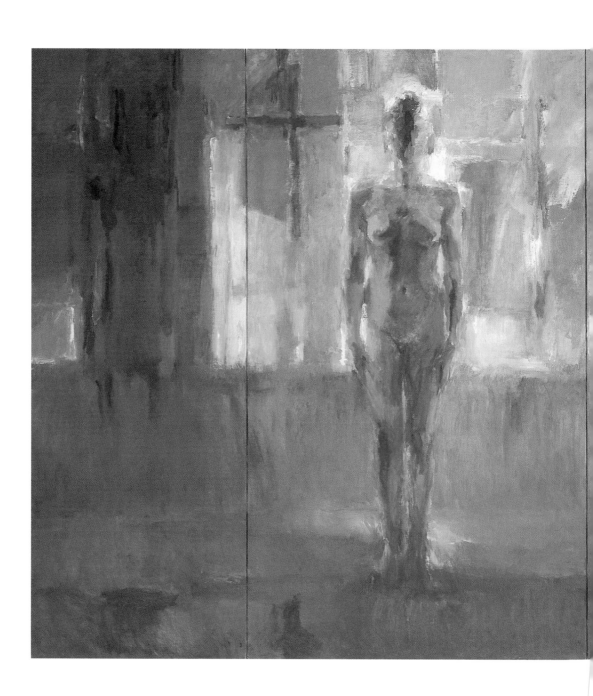

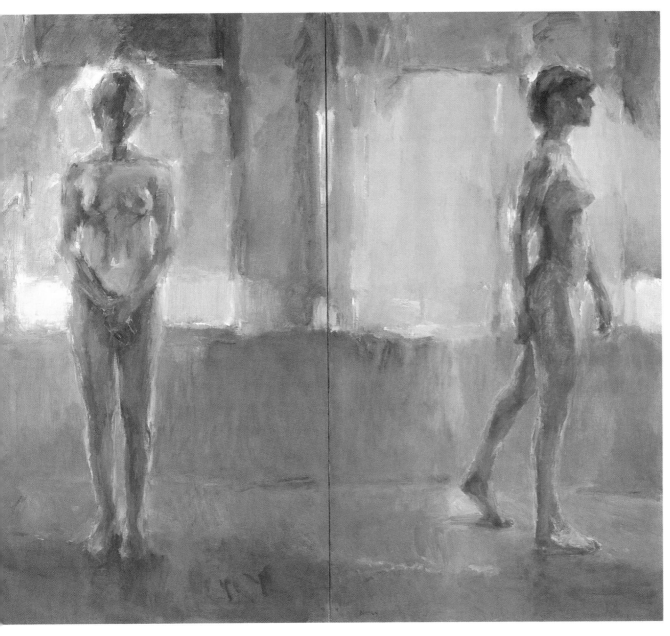

Frieze, 1994
oil on linen, four panels
60 1/4" x 124"
Collection of Steven and Nancy Schwab

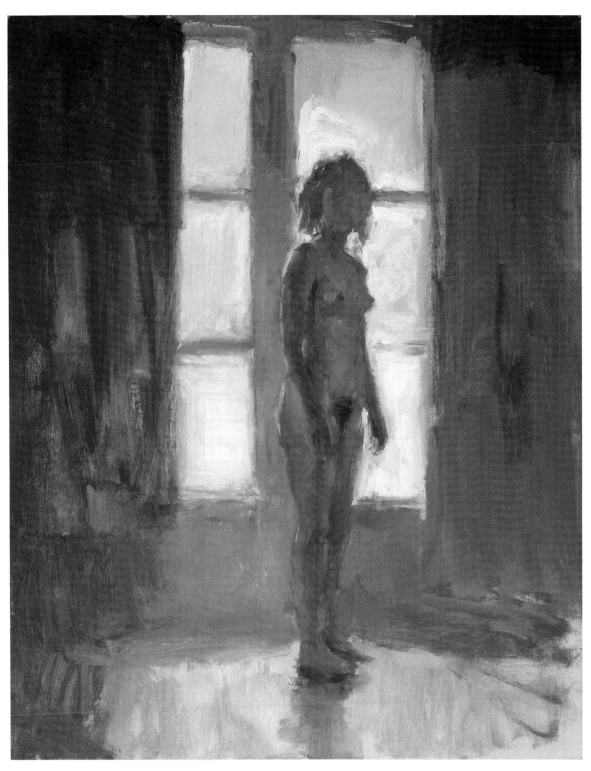

Emily in Front of a Window, 1992
oil on linen
30" x 24"
Lent by the artist

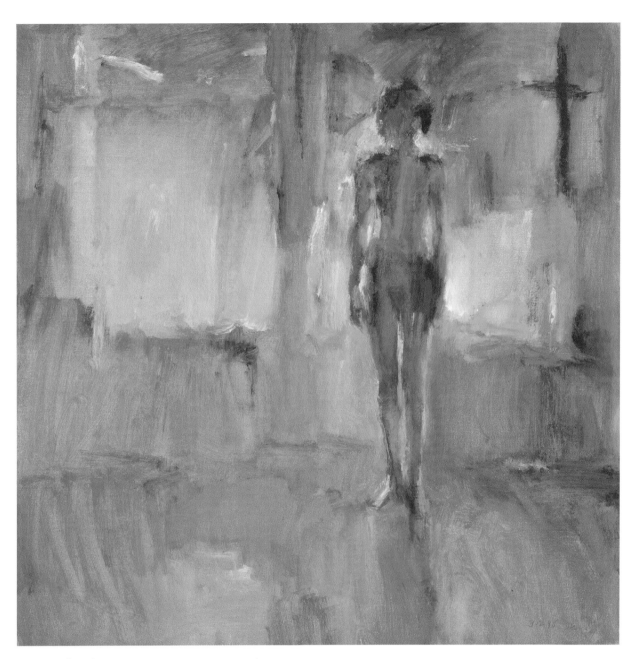

Stacey with Red Cross, 1995
oil on linen
24" x 24"
Collection of Fred and Victoria Dalkey

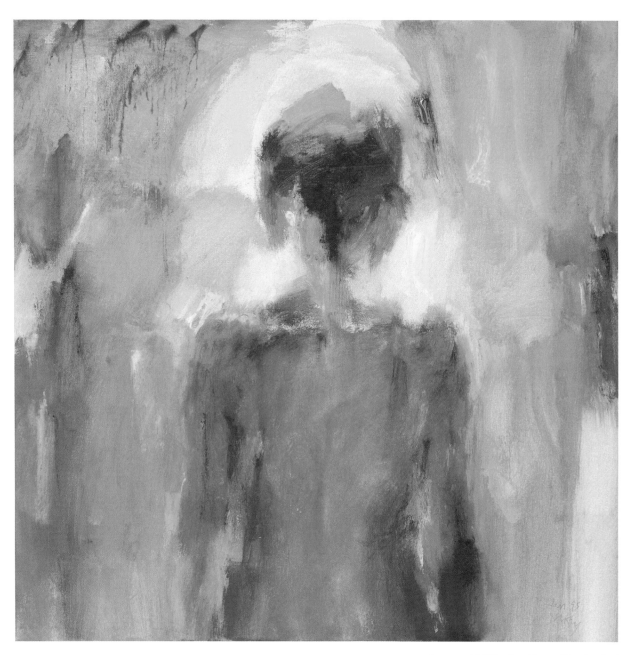

Stacey with Weeping Green (Kore), 1995
oil on linen
24" x 24"
Collection of Fred and Victoria Dalkey

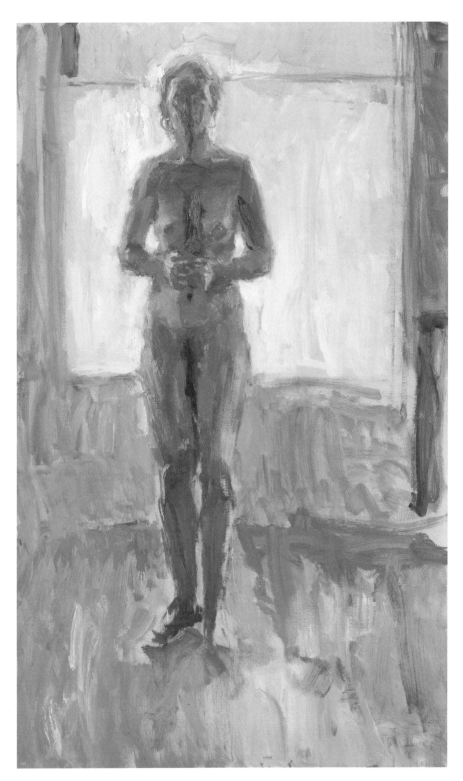

Tabitha, 1993
oil on linen
50" x 30"
Collection of Mr. and Mrs. Harry Parker, III

Red Sky at Morning, (prepatory drawing), 1996
sanguine Conté on paper
11" x 6 3/4"
Lent by the artist

Red Sky at Morning Sketch, 1996
charcoal and oil wash on linen
26" x 16"
Lent by the artist

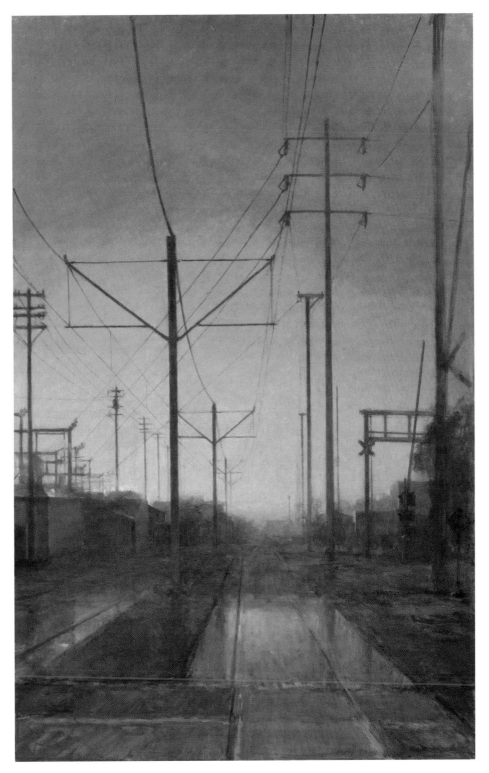

Red Sky at Morning, 1998
oil on linen
68" x 44"
Collection of Gregory and Andrea Trautman

THE DRAWINGS OF FREDRIC DALKEY

RICHARD WOLLHEIM

Fred Dalkey is that rare thing nowadays: an interesting artist. And this means, not only that his art rewards the interest we take in it, but that it requires this interest of us before it offers us the rewards it promises. In an age when so many artists have got under our skin before we have even been made aware of their presence, an art of this dignity, of this slow disclosure, deserves attention and acclaim.

The distinctiveness of Dalkey's drawings comes from the extreme way he has reduced the range both of his subject-matter and of the physical materials that he uses, and in each respect, done so with such a sharp eye upon the other as to bring the two into total accord.

The subject-matter is invariably a human body, or something that stands in for it, a background, and a diffused or sourceless light. The contours of the body and the line of the horizon where the ground meets the floor are greatly attenuated. The materials are sanguine, and a handmade laid paper, generally with a prominent texture. The sanguine is employed in two ways. Used to record the facts of an initial session in front of the model, it may then be left unadjusted, in which case hints of blue and violet are observable, like the taste of wild berries in a wine.

Alternatively, the sanguine is "blended," or burnished with a "stump," or tool made of tightly wound paper, and then it takes on a brownish, velvety warmth and richness reminiscent of Venetian art. The exposed areas of the sheet provide the highlights, and sometimes, through the cunning use of juxtaposition, these passages are made to seem lighter in tone, or closer to white, than the actual paper itself.

The use of a single stuff harmonizes the figure and the background, and ensures that there is no harsh contrast or severance between the two. At the same time the effort that has to be put into the construction and articulation of the figure with such limited resources, the enforced attention to the slightest variations within the sanguine deposit, prevent any peremptory merging of the two. Body and ground keep their distance like the finely differentiated layers of the lowest Florentine relief.

And then there is the third thing: the light. Like a substance, or like the medium that a classical god might have assumed in order to seduce a mortal, it inserts itself between the figure and the ground, it creeps between the model's legs, and it holds her breasts apart, and encircles her pubic hair, and we cannot tell, as we peer at the drawing, exactly how this light becomes, if not the most

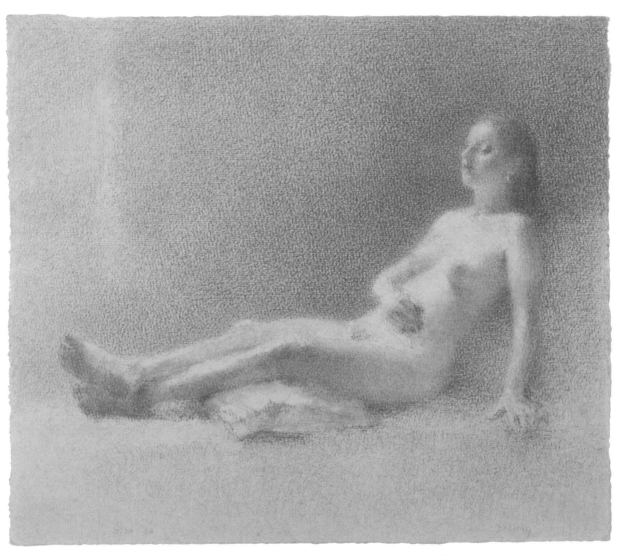

Model with Dirty Feet (Elizabeth), 1996
sanguine Conté on paper
8 3/16" x 9 3/16"
Private collection

solid, certainly the most insistent, the most robust, element in the work.

It is habitual to call drawings that look in some way like these, whether they are by Ingrés, or Gericault, or Picasso, "academic." In the case of these drawings, there are two clear reasons why thinking of them in this way would be an absurd mistake.

In the first place, academic drawing, like academic poetry, or academic philosophy, pursues a predictable course: that is to say, it sets itself a number of problems, and then it sets itself to solve these problems. By its lights, failure or defeat comes about when the drawing either leaves some of these problems unsolved or, in the course of solving them, gives rise to new problems. Serious, in contrast to academic, work does the opposite. It concedes failure if the problems that it has taken on can be solved in such a way that their solution does not point beyond them to further problems, to new work, to fresh understanding. Look at one of Dalkey's drawings, identify the pose, then imagine another pose to be adopted, and we have to recognize that we have no clear idea which aspect of the new pose the medium would appropriate and make its own.

Secondly, there is the flow of life across the margin of the drawing into a world outside. The young woman is not any woman from anywhere, nor is the dirt from the floor that blackened the soles of her feet any dirt, nor is the wall against which she is silhouetted, or upon which she casts a shadow, any wall, nor are the time and the light any time, any light. The model, the place may be anonymous, but that doesn't mean they are without names: it is we who don't know them. Classical up to a point, these drawings nonetheless reek of particularity. Worked upon with love and hard labour in a dingy studio a walk-up from a sidewalk in Sacramento across from a small municipal park, they have preserved from the circumstances of their origin as potent, as skunklike, a sense of place as Hopper. The violets in the expanses of unblended chalk warn us of the banality, the monotony, the melancholy, that lie in wait for us beyond the edges of the drawing. If, looking at these sheets, we can, at any rate in certain lights, feel warm and safe, it is not the drawing itself that does this for us, it is another thing, something that emanates from the drawing, not mentioned until now, or its beauty, which defends us against the ache, the sense of frailty, with which it throbs.

Richard Wollheim, Professor of Philosophy at the University of California, Berkeley, is the author of Painting as an Art, *(Princeton University Press), among other works, and a frequent contributor to the international art journal* Modern Painters

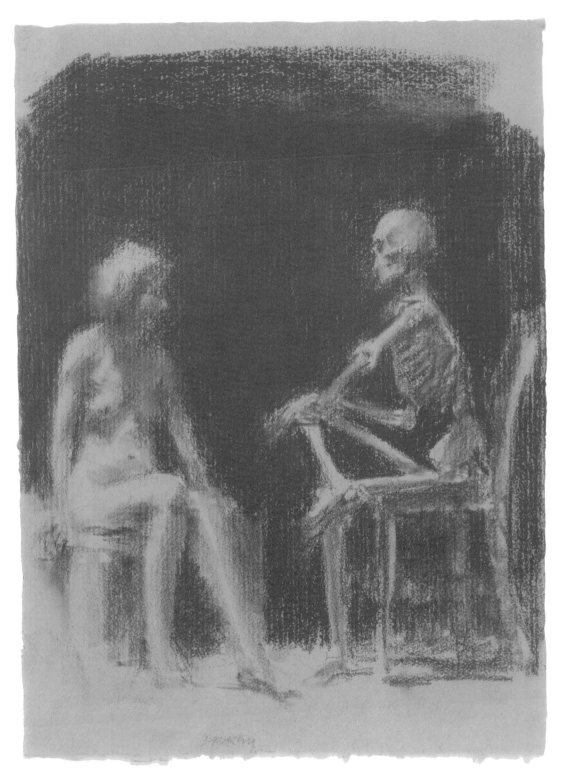

Life Class, n.d. (c.1985)
sanguine Conté on paper
13" x 9 1/2"
Collection of Fred and Victoria Dalkey

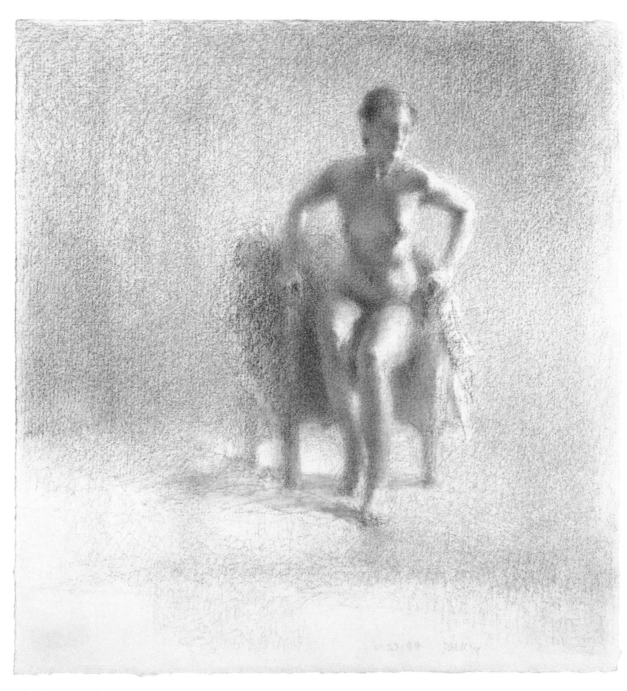

Julie Rising, 1994
sanguine Conté on paper
9 1/4" x 8 3/4"
Collection of Russ Solomon and Elizabeth Galindo

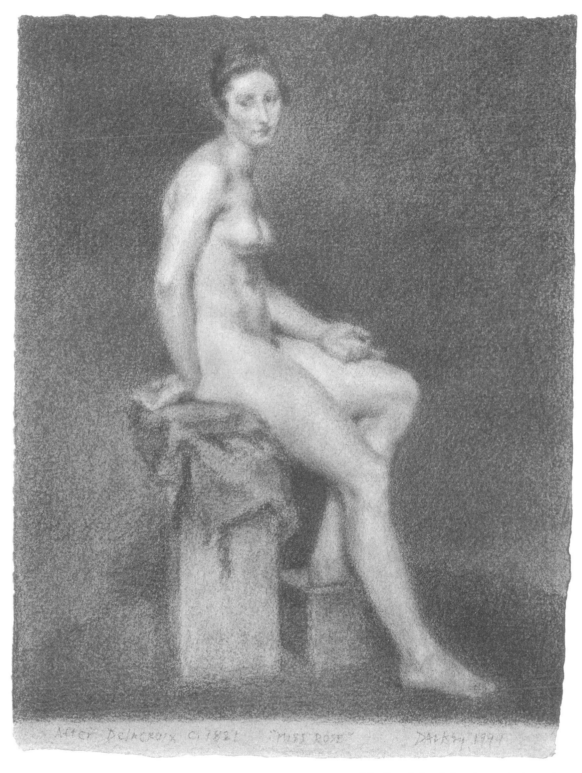

Miss Rose (after Delacroix c. 1821), 1994
sanguine Conté on paper
9 5/8" x 7 1/2"
Collection of Wendy Turner

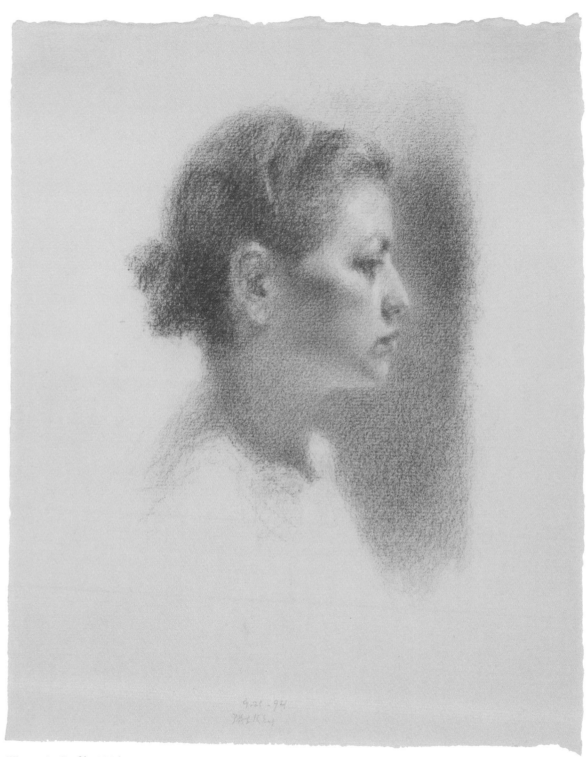

Woman in Profile, 1994
sanguine Conté on paper
10 5/8" x 8 3/4"
Collection of Anne and Malcolm McHenry

Skull on a Table, 1994-5
sanguine Conté on paper
8 1/8" x 10 3/4"
Collection of Larry Evans Fine Art

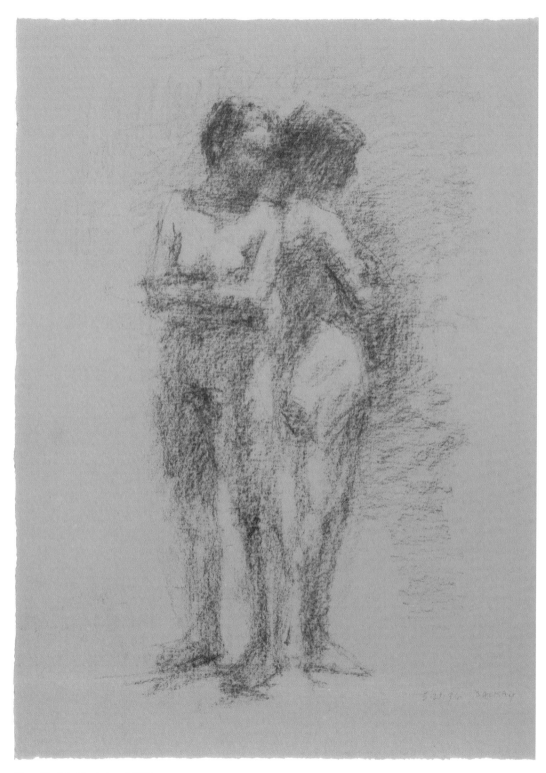

Two Models Gossiping, 1996
sanguine Conté on paper
9 15/16" x 7 9/16"
Collection of Charles and Glenna Campbell

Pablo's Mistress, 1997
sanguine Conté on paper
8" x 8 1/4"
Collection of Frank Caulfield

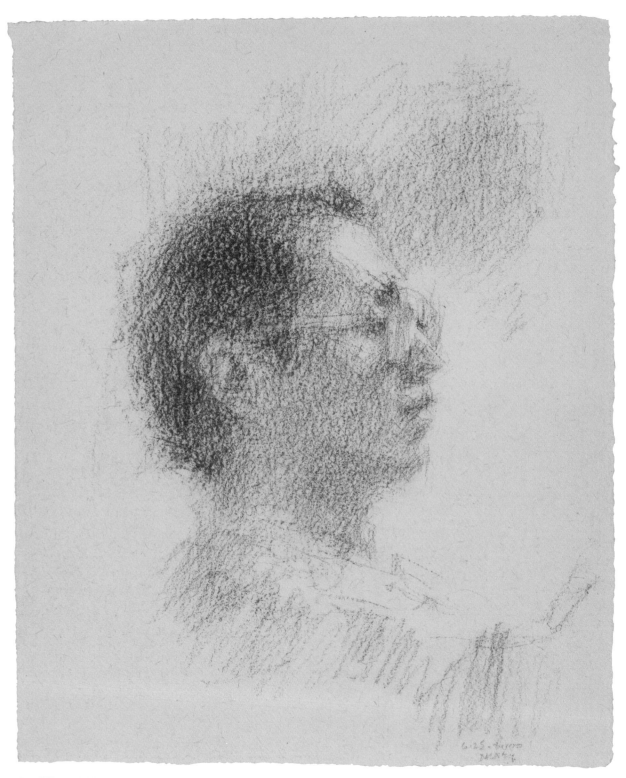

Jian Wang, 2000
sanguine Conté on paper
8 7/8" x 7 3/8"
Lent by the artist

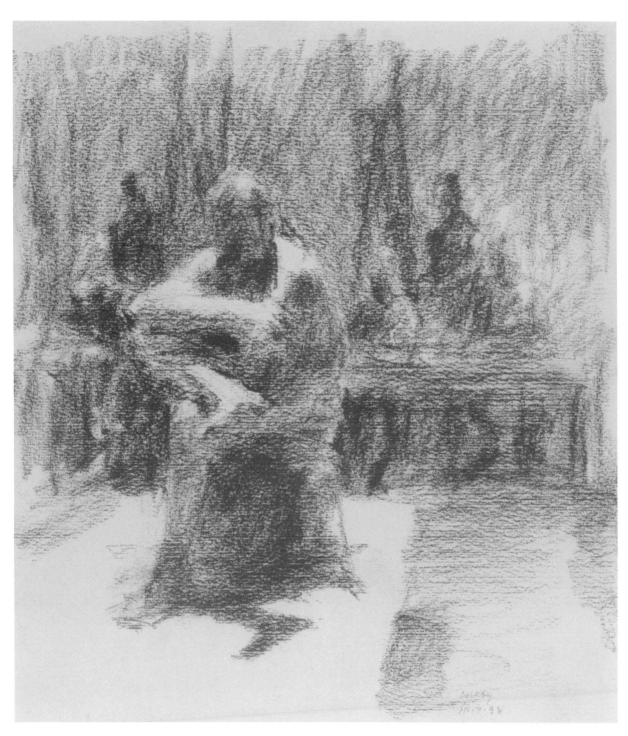

Kim Modeling in the Classroom, 1998
sanguine Conté on paper
9 7/8" x 8 7/8"
Lent by the artist

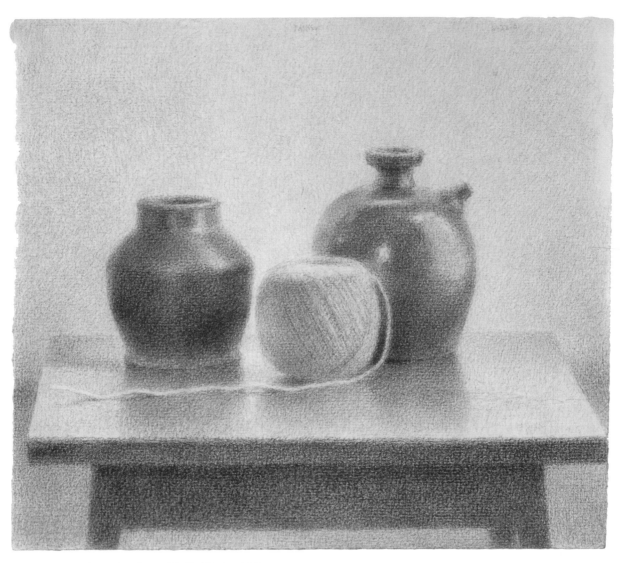

Ginger Jar, Soy Sauce Bottle, and Ball of String, 2001
sanguine Conté on paper
9" x 10 3/8"
Lent by the artist

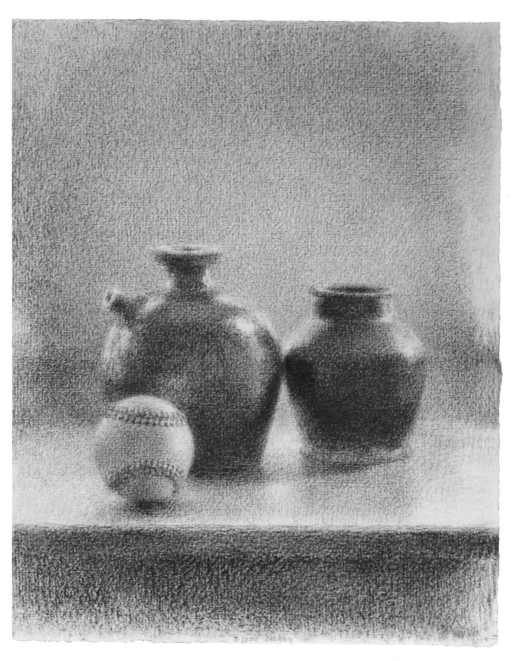

Ginger Jar, Soy Sauce Bottle, and Baseball, 2001
sanguine Conté on paper
9 7/8" x 8 7/8"
Lent by the artist

INTERVIEW

CHRIS DAUBERT

INTERVIEW with Fred Dalkey regarding paintings and drawings in his retrospective exhibition at the Crocker Art Museum by Chris Daubert, Tuesday, June 19, 2001, at the Dalkey residence.

CHRIS: After they're finished, do you look at your pictures as a record of their making or do you look at them for content?

FRED: I think it varies, and it varies over a period of time. There's a period where I want to look at [them] to absorb what might have occurred, and then there's a certain point where there's a profound sense of wishing I hadn't done that. So, I avoid the work, putting it away somewhere and not wanting to look at it and go on to other things. Later on, the work kind of sneaks back to me and I start seeing things that I hadn't seen before.

CHRIS: So, in the long run, they still have that dual function of both being a drawing and a picture?

FRED: Oh indeed. One of the things I find true, not just of my own work but all work is that it's work in progress. I'll still go back through things and find things that are many years old and either destroy them or pull them out and think, well, these are interesting, more so than I had thought at the time.

CHRIS: I think it's pretty interesting, this history of erased Dalkeys. You'll find a piece of paper you like particularly well and you'll draw on it and erase it, and draw on it again and erase it again.

FRED: Well, there are certain papers that are just no longer available.

CHRIS: There's a very slow, contemplative quality in the drawings.

FRED: Sometimes. I usually try to start a work with the thought that this is going to be done with dispatch – that it's going to work quickly, but it doesn't necessarily. There are works that lose that urgency and take on another element. Quite often the works that are quite refined actually started out as rather loose works. It goes way back to the kind of training that I had with Abe Nussbaum in the 1950s. He always thought that a work should be started quickly and he talked about the sweeping layout. So, really the foundation of his approach to doing portraits, even though his work was extremely refined, involved the gesture developed in a very quick, broad manner in a matter of seconds, the gesture of the entire image, and then the refinement would start coming into it after that. But it wasn't started with a kind of meticulousness from the get go.

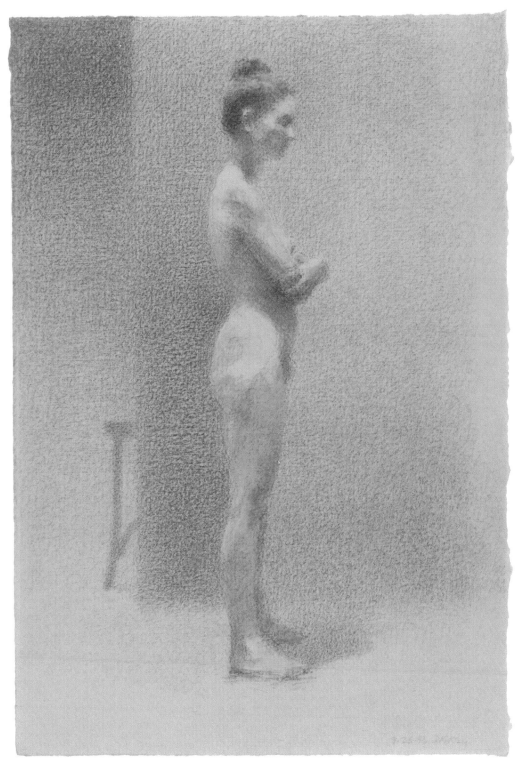

Kristin with Chair Leg, 1996
sanguine Conté on paper
10" x 6 7/8"
Collection of Tony and Eli DeCristoforo

CHRIS: Do your drawings, especially the finished Conté drawings, start up as gestural contour drawings and then develop into a refined value drawing?

FRED: Yes. I think one of the things that over the years has been characteristic of my drawings particularly and my paintings to a certain extent, is an immediate engagement with value structure. I've tried to make a point of not making a fixed mental image between the positive and the negative space of the form, so that I can enter into the background or into the figure simultaneously, and I do that through value.

CHRIS: As you're completing or refining a work, I've noticed certain almost purely formal elements that are added into the image that weren't there at the point of observation. In one of the figure studies, you added the leg of a chair that perfectly reflected the curve of the calf of the model. That chair wasn't there originally, was it?

FRED: No. One of the things that I sense as I'm going along is a feeling of incompleteness and a lack of tension. I have to start addressing that idea of tension in terms of pulling away from the figure. I've felt this with painting and drawing for many years: the real struggle is not necessarily with drawing the image, but drawing the rest of it. I suppose I'm kind of a primitive. I think maybe I'm doing sculptures that don't require backgrounds. But ultimately, since they're on paper or canvas, they do require backgrounds, so that's the area I have to work on.

CHRIS: It seems as though you create certain challenges, especially in the paintings. You say, I'm going to complete this entire painting in three hours or I'm going to complete this drawing in a sitting.

FRED: That's the irritant that makes me want to work. I'll do that in terms of even laying out a palette for a painting. I'll put in colors that I wouldn't normally think of using in that context, in order to create a challenge, and quite often when I start a painting, I'll start with colors that are quite raw, very high chroma, and then have to battle that out. How do you reconcile a big purple nose in terms of the context of the whole painting? So [the paintings] become kind of battlegrounds. That really is what finally is interesting to me.

CHRIS: I'm surprised by the anxious quality in your works, even in the refined drawings where that battle still feels very specific, to the point of almost taking the risk of losing the piece.

FRED: It's interesting, after you've invested a month in a small drawing, and you look at it and you say, oops. And there it goes.

CHRIS: All these questions address a dual response between the making and the viewing. At what point are you thinking about both these things?

FRED: I don't know. That's a great question because I'm not sure how much I think about them being looked at. I suppose I do, but I can

spend a great deal of time, by most people's definition, wasting time, overworking things, doing various things that probably wouldn't make any difference to anybody looking at the work, just simply because of my own preoccupation with the process. I've never been terribly comfortable about the idea of the ultimate completion of a work, which is the viewing of a work.

CHRIS: There's a sort of immediacy in looking at the works. They seem to open themselves up in a fairly quick and somewhat dramatic way, as opposed to feeling as though there was an awful lot of hidden intent.

FRED: No, I don't think there's much hidden intent. I don't think in those terms. The works are really in the process of trying to become what they are, and they are pretty much on the surface that way.

CHRIS: There seems to be a resonance in them which is more than producing products. There's a feeling that has to do with contemplation and a basic humanity. The investment in each one seems to be fairly specific.

FRED: I can't claim any kind of holy pursuit – that there's no product involved in it just because I think there is no product. Finally, you've made this record that sits out there and stares at you and stares at anybody else and represents you. But, I think one of the things that involves me in terms of a motive is an odd one. It is a way of getting over the embarrassment of the last one. I think that's one of the things that will allow me

to do figure drawings endlessly, thinking maybe I'll get it right.

CHRIS: You have said that a lot of your most compelling images of the nudes and the landscapes that people see as having a strong emotional resonance, you don't really see as being as emotional as the more abstract works.

FRED: Right. I was thinking about [emotion] in the process of working with [the abstractions]. Later on, with the figures and landscapes, I don't think that I thought about that to any extent. Sometimes I think about – rather than emotion – tone.

CHRIS: Are you talking about how major and minor would work in music?

FRED: Yes. It's emotion, but it's not emotion that you could put a name to. You can't say happiness, sadness, all of the various kind of cheap names that we have for what we think of as our emotions. There are emotions, for instance, just to the tone of the air between me and the bookcase over there.

CHRIS: I know how careful you are to avoid any kind of prurient feeling in how the female figures are presented. You're very careful to have a certain equanimity of emotional distance. Would you describe your approach to the nude as essentially classical, or is it observational?

FRED: It's observational. I'm not sure that I would think of it as being academic, but it certainly is connected to the academic, because

I've been teaching figure drawing for 30 years, almost every semester. And, before that, I was taking figure classes. So, it just became part of a routine of working. In the process of teaching about it, I continued doing it, and right after I would talk to a class, I'd sit and do some drawing. So, this is an ongoing process. I don't think that I think much about that element of the prurient. The reason that I think the figure works for me is that it's a terribly compelling image, more so than, for instance, an orange, or…

CHRIS: Not to say you haven't drawn baseballs.

FRED: I have done still lifes, but those are the exceptions. The figure immediately carries with it a jolt of interest. So, in a sense, the figure takes care of the worry about content.

CHRIS: There's a difference between the figure drawings and the figure paintings. [In] the figure drawings, there's a dual sensuality [in] how the figure is caressed by a beautiful drawing process, as opposed to the paintings which are almost brutal in their handling.

FRED: There's a certain element of praise involved in the process. I don't mean it's a compliment or you're trying to flatter. I don't mean that in the least bit. It's closer to an appreciation. It can be an appreciation of a landscape or it can be an appreciation of a figure, no matter who the figure is, male, female, Diane Baxter in her monumentality, or Emily in her delicacy. There's an appreciation of that, and a giving of thanks.

You give thanks to a nose, just for being there and being this kind of wonderful thing. And this is true of a figure, very definitely true of a figure. If there is an eros in those works, it's that.

The paintings, on the other hand deal with my relationship to paint and also to a kind of panic level. I set a boundary for myself, thinking I should get this painting done no matter what within a certain amount of time. I wanted to see what happens when you put yourself under those kinds of restrictions, to see what kinds of conventions will develop, not pre-conceived conventions, but conventions that will develop as you progress.

When I was working on those paintings, I was really not trying to paint a replication, but a correspondence. The paint itself has a real limited range from black to white, from red to blue, or whatever. In nature the range is infinitely greater. What you're trying to do in a painting is to create a logical correspondence to what you're seeing in order to have some of the intensity of what you're seeing. What you're seeing is so much more wonderful than the tools that you have at your disposal. They seem to be kind of a frail arsenal.

CHRIS: Why is your handling of the landscape paintings much slower than the figure paintings?

FRED: I suspect that I'm fundamentally a portrait painter, and if I'm doing a landscape, I'm doing a portrait of a landscape. Portrait is a slow kind of process, and I don't have much ability [with landscape]. With the figure, I have a lot of ability, and I've been doing it so long that I

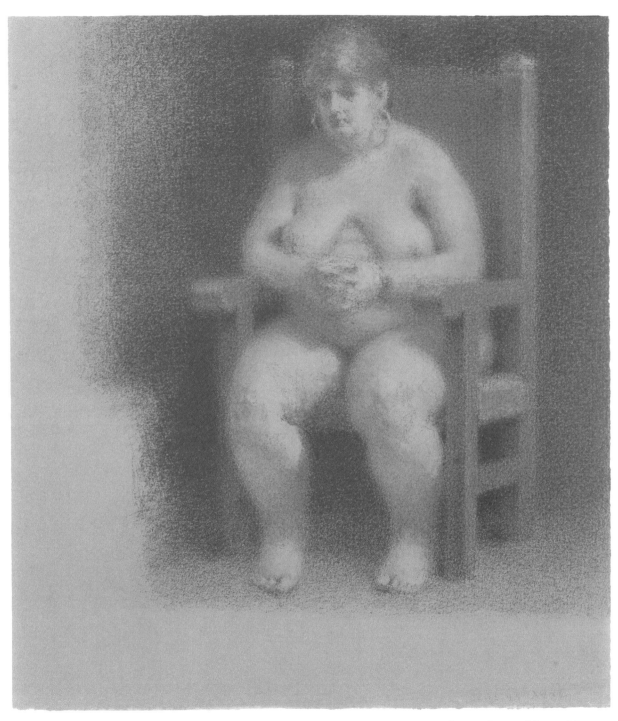

Diane, Queen of the Models, 1998
sanguine Conté on paper
9 1/2" x 8 1/8"
Lent by the artist

suspect that I know something about the length of the arm, or whatever it might happen to be. The landscape always catches me by surprise. I just don't know what's going on. So, I have to go slowly.

CHRIS: Do you go searching for landscapes, or do you know when you go out in the morning where you're going to go to?

FRED: No. I don't know. When I was doing those urban landscapes, there was a certain area that I was fascinated by. I was fascinated by it because it was just silly, haphazard. On the one hand, when I started working, I thought this has got to be the ugliest place around, and as I looked at it more, it started transforming itself for me, and I kept being surprised by this radiance that had developed.

CHRIS: Do you see these landscapes as portraits of a specific place?

FRED: Well, I do. I think of them that way. My approach to painting anything, I think, essentially is a kind of primitive portrait approach to things. Again, it has to do with tone. I think that I'm perhaps more attuned to listening to the sound color of the situation.

CHRIS: I see them as a correspondence between the solid elements of the ground and the formal elements created by the wires in breaking up the air. The infusion of the light and the time of day is a unifying feature.

FRED: I really do like those wires and all those poles and what not, because even though there's a traditional linear perspective in them, they allow for a flattening out of the painting, of a network of lines that divide up the canvas, somewhat as Diebenkorn did in his Ocean Park series.

CHRIS: I'm not particularly interested in who your influences are as much as the way the works really stand on their own.

FRED: There are some things though. There's a particular Vermeer painting where there's a woman in the background of the painting and the only thing you can see are her eyes, because the value of her skin and the value of the wall behind her are so close, she's almost vanished. So, you can see some hair and you can see some eyes, and this thing is so radiant in its disappearance.

One of the things that I've been playing with in those very involved figure drawings is the disappearance. When something vanishes, it becomes extra focused in some peculiar way. I don't know if you remember the kind of psychological value test where you have a pole going from white to black, and from black to white, and it's that point where those two cross that becomes an incredibly important element. It's much more interesting than where the contrasts were. It's where the contrast ceases to exist that's just absolutely compelling, riveting. And I think that Vermeer painting has that quality where she vanishes, literally.

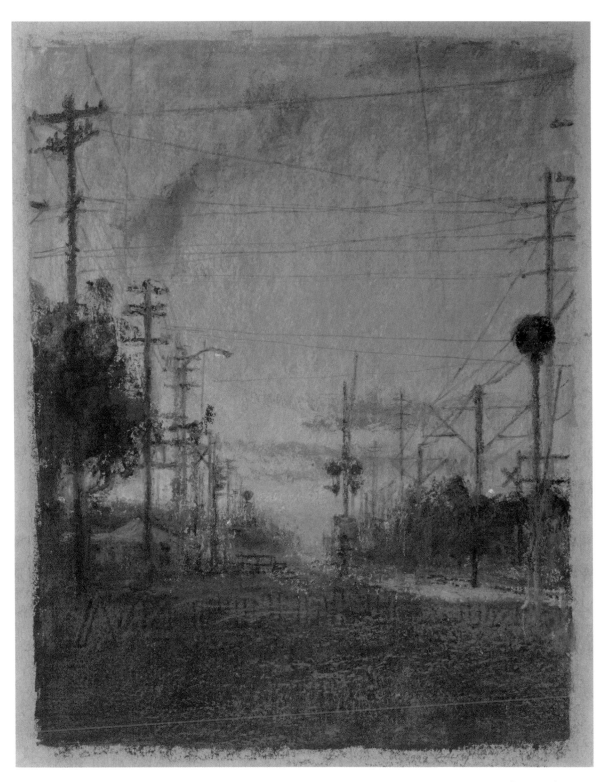

Predawn Light, 1998
oil pastel on paper
9 1/4" x 7 1/2"
Collection of Burnett and Mimi Miller

I love playing with that element of invisibility. I think there's a very interesting thing that I've worked with in color. When a shadow, either a cast shadow or the shaded side of an image, is just right, the advantage is you can't see it. It somehow convinces you so totally that it ceases to exist as a recognizable image and just integrates and somehow diffuses into the overall content of things. And that's really wonderful when that happens. I think it's very risky, because if the thing vanishes enough then it just seems normal.

CHRIS: How do you finish a drawing? How do you finish by adding that which isn't just there?

FRED: The work that I've done essentially that interests me is work that in some way or another starts telling me what it has to do.

CHRIS: While it's being made?

FRED: While it's being made, during the process of it. You try various ways of getting that to occur. For instance, with the drawings, there's a certain point, and a desirable point, where a work gets out of hand, where it's no longer what you thought you were going to do, but it's what it's going to do. Eventually, it reaches a point where you almost are watching it happen. You're having to do it, of course, obviously, by manipulations of textures or manipulations of values, going back and forth between picking darker tones into light tones, or picking light tones out of darker tones with an eraser.

There is a certain point where the whole work starts taking on what is ultimately very important for me: a feeling of air. And, that's probably what I think of those works as being about. Most of the work that I'm trying to do, is less about the object and more about the air between you and the object, and the kind of, I suppose, light. But, light is really a function of that air. I think always the most fascinating color to me is the color of invisibility. If I look into a darkened room from a light room, what is the color there of the air in that room? It's almost a chamber of a particular kind of haunted gray.

CHRIS: Can we talk a little bit about the centrality of the figure. You get the focus to go first to the figure, but it expands out to the edge of the image then back to the figure again by essentially those negative spaces that are so embodied by light. What is that about?

FRED: I think it's about guilt, and that sounds silly. I remember reading one time, years ago, that there were two essential kinds of painters. The writer traced it to childhood. There are the kids who fill up the page with mad compositions that are wonderful, and then there are the others who will take a big piece of paper and draw a little picture in the middle of it, and that was me. It took me years of working to be able to really think about composition. My biological inclination was to the object. I knew that was wrong. There was some kind of fundamental moral failing on my part and I had to try to address this thing, so I started making a very conscious effort

to try to spread that image out away from that fundamental interest in the thing to the point where I kind of finally lost interest in the thing. So, probably the most conscious part of my work is that attempt to confront the image or the object and the environment simultaneously. I have to work very hard at that.

CHRIS: I know that you have an encyclopedic, rich knowledge of art history. Are there artists that you look at that wouldn't be readily apparent by looking at your work?

FRED: There are artists that I've liked very much, more than like now, just am completely moved by. It wouldn't show up in any way other than very peripherally. Matisse. Not the flatness of Matisse, but in fact the opposite, with Matisse having this wonderful kind of air and space. When you look at a Matisse, when you stand very close to a Matisse, you feel like you could fall into it. Somebody said that they looked like they were painted on scrims. That spatial aspect of Matisse I find very fascinating.

CHRIS: How often do you find yourself repeating what you were taught by Abe Nussbaum?

FRED: Well, there are times when I go back and I pick up loose ends, and I think that sometimes I pick up his processes. I'm working on a painting right now at the studio. I'm starting a charcoal drawing and doing a wash drawing on that. And I think it's because of reaching back for some kind of security. Oddly enough, it's a

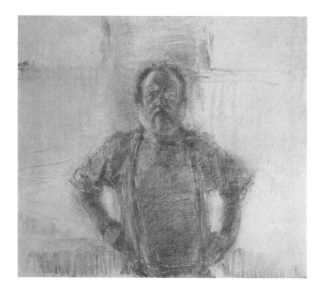

Self-Portrait with Hands on Hips
(preliminary underdrawing), 2001
charcoal on linen
28" x 32"

peculiar commissioned work, and the minute that notion of commission comes in, that element starts creeping back into the work, the things that I learned with that commission portrait technique. One of the reasons I abandoned that process, that layering of charcoals or grisaille wash or under-painting is that it tended to make engaging the overall color statement of the painting more difficult. Because it really did isolate down onto an object. So, in trying to compromise that, I decided to deal with the image as an entire painting, as opposed to creating a piece of sculpture.

CHRIS: You worked with Wayne [Thiebaud] for such a long period of time, but your work is so dissimilar in many ways. In the studio while you were working together, did you pick up

anything, not pointers, but just the fact that there was another artist working next to you in a style which is not the same style you were working in.

FRED: It had a real effect in terms of the notion of the seriousness of the engagement. He was very serious about his engagement with the model or with the drawing. His attitude was: This is work; this is very serious. And I think that everything we did was certainly of a very intimate seriousness together. That was very enjoyable. I also was always struck by how different our perceptions were, and how different our approaches were. I tend to be more flamboyant, quicker. He's a much more calculating, careful worker. I would tend to do 10 drawings and he'd do one drawing. My 10 weren't as interesting as his one, but…

CHRIS: Can you just elaborate one little bit more on the relationship in the drawings from that part which is done at the sitting to how they are finished when you work on them after the sitting.

FRED: Well, some of them are actually done on the spot. The ones that get – Paul Thiebaud calls them "heavily leaned into" – the heavily leaned into works are works where I have enough information that I feel that if I was to work on it longer, refine values, or do whatever, I wouldn't lose it. There was enough factual information in my mind and on the page itself from that session that it affords that. If [I] have enough information, value information, anatomical information, I feel comfortable enough that I can start playing

around, making alterations without feeling that it'll disappear. Sometimes they do. All of a sudden a leg will vanish and you can't remember what on earth the thing looked like, and so that's the end of that one.

When I first enter the process, I'm looking for light. I'm trying to get the light to be particularly resonant in the work. That might engage background value, but immediately that will engage the figure again, so I have to go back and adjust that. It's the kind of give and take that occurs. After the value is established, after the sense of radiance or luminosity of the figure, then there's the equal luminosity that I've been looking for in the values in the background, and they also have to have the same resonant light.

CHRIS: It seems like your play of light against the highlights and the shadows in the figure, the shapes that you make in the backgrounds, invariably corresponds to the complementary value in the figures.

FRED: At a certain point, the work becomes your memory, as opposed to a photographic recollection of what you were looking at. And so, the point that I'm looking for is when it clicks over and the work itself becomes the image and its own history of the work, if you can make sense out of that.

CHRIS: So, the scraps of paper on the floor or the table that might have been in the background essentially just cease to exist.

FRED: Yes.

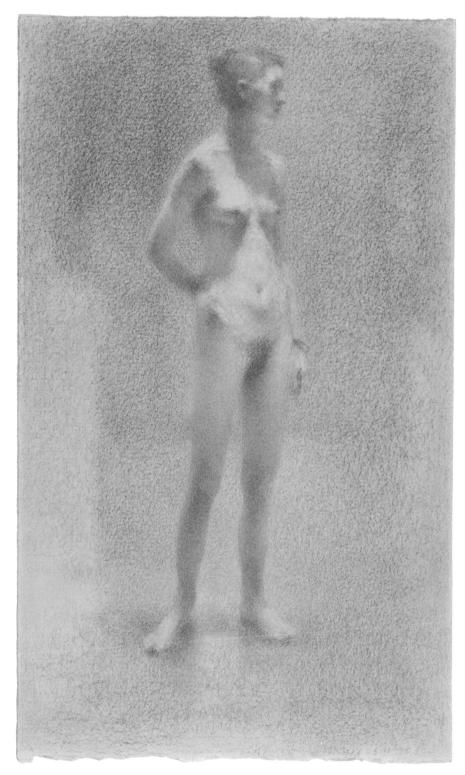

Therese with Bracelet, 1995
sanguine Conté on paper
11 1/16" x 6 11/16"
Private Collection, San Francisco

CHRIS: Do you consider these drawings to be idealized?

FRED: Well, no, I don't think of them as idealized, oddly enough, even though I suspect that they are. When I'm talking to you and looking at you, I'm thinking of what would transpire if I were to draw you right now, and there would be all kinds of things that ultimately would leave, and maybe at a certain point you'd say, well, that's very idealized. But that's only a way of getting to a larger truth than the photographic truth, which is the truth of the light that surrounds you, which is the air in the work.

CHRIS: Is there any fundamental difference between drawing a standing nude and doing a fairly overt portrait of someone where the intent is a representation of that person?

FRED: Somebody said one time, or I read somewhere, that a figure painting cannot be a portrait or it becomes something else. You have to somehow submerge that portrait nature. I'm never quite sure where I am with that, because I'm inclined, when I'm doing a drawing, to try to be fairly specific as to this being this person as opposed to any person.

CHRIS: One thing I was going to talk about in these figures is the fact that persona is held in the body of the figures as opposed to only in the head. The entire mood and feeling of the person is held in the entire body.

FRED: Well, I think that's very much a part of what's interesting in doing figures in the first place. You can recognize somebody at 100 yards and you're certainly not seeing their nose.

CHRIS: Could we talk one little bit more of some of the concepts of specificity and place in the landscape? When you're concentrating on the air and the space and the personality of that location, are you trying to capture the immediacy of that thing which you see or a recollection of that place?

FRED: They're more recollections. They're more recollection than they are *plein air* painting.

CHRIS: Is it a memory of the time that you were there painting it, or of the time knowing that location in general?

FRED: Boy. I think it has to do not so much with specifically that place, but about a particular time. It's not so much wedded to that spot as it is wedded to looking for a certain kind of light that I might have seen three days ago at a certain time. There's a wonderful feeling of tarnished silver to the sky, or something. So, you start with that and the work itself sets up its own logic.

For instance, people ask, how do you paint skin tones? Well, you try to get one of them right and the rest of them will fit. If you decide that a shadow is cadmium red, it's going to determine a logic for the entire painting that will allow that cadmium red shadow to function in the painting. And that would be true if I established a certain

area of one of the landscape paintings that I'm comfortable with and say that is that particular moment, and the rest of the painting will have to be adjusted to that.

CHRIS: That gets back to what you were talking about, that [the work] becomes the memory. The painting actually becomes the memory of that time, because that cadmium red will actually affect the color of the sky.

FRED: Sure.

CHRIS: So, it's a very collaborative process between you and this image which is developing.

FRED: I think so. They really don't exist, those places. I thought they did at one point. I thought, these are just really dumb. This is just the way it looks. And then I realized, no it isn't really at all the way it looks. Maybe it's just the way I want it to look.

1943 Born on February 22 in Sacramento,
California, the second of three children of
Frank Ferdinand Dalkey and Susan
Dynan Dalkey

1945 Begins drawing, mostly images of
locomotives

1949 Catches large carp at William Land Park
pond and becomes an avid angler, fishing
in local park ponds and in the Sacramento
River and Delta sloughs

Develops an abiding love of the dark and
mysterious waters of ponds and sloughs

1955 Attends Peter Lassen Jr. High School
where one of his teachers is artist Larry
Welden. Becomes more interested in
drawing and copies photographs, many
of his hero Arturo Toscanini

1957 Attends Sacramento High School.
Begins private studies with Abe Nussbaum,
an Austrian artist who settled in Sacra-
mento after World War II. Nussbaum, a
portrait painter, was the student of the last
court painter to the Hapsburgs and also
played first violin with the Vienna Philhar-
monic. Nussbaum gives Dalkey a rigorous,
classical training in art and also encourages
his love of classical music

Fred Dalkey, two years old, 1945

With carp, 1949

1958 Attends Hiram Johnson High School.
 Gets first portrait commission

1959 First art show at the Guild Theater in
 Oak Park

1960 Graduates from high school and ends
 studies with Nussbaum

 Wins Art League scholarship to Sacra-
 mento City College. Studies with Larry
 Welden, Patricia Tool, Gregory Kondos,
 Amalia Fischbacher and others

1962 Group show at Barrios Gallery

1963 Attends Sacramento State College.
 Studies with Robert Else, Jack Ogden,
 Irving Marcus, Ruth Rippon and Hans
 Hohlwein

 Wins first place in watercolors at
 California State Fair

 Pays for his schooling by playing in
 The Sutterville Stompers, a folk trio,
 with John Berg and Rodger Hille and
 as a single act in clubs and coffeehouses
 playing blues and folk music on guitar,
 banjo, autoharp, balalaika and other
 stringed instruments

1965 Wins second place in oils at California
 State Fair

 Serves on Cultural Programs Committee
 at Sacramento State College and as art
 editor for *The Levee*, campus literary
 magazine

1959

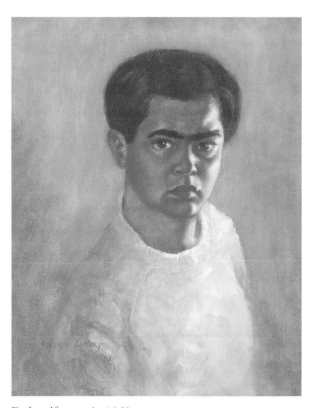

Early self-portrait, 1960

1966 Earns B.A. from Sacramento
 State College

 Marries Victoria Sellick

 Works as a guard at Crocker Art Museum

 Begins graduate work in printmaking
 under Hans Hohlwein at Sacramento
 State

1967 Included in "Young Printmakers" show in
 Los Angeles

 Spends much time at convalescent
 hospital where Victoria's mother is a
 patient

1968 Victoria's mother dies

 Shows in Kingsley Annual at Crocker Art
 Museum

1969 Son Emile Sellick Dalkey born in March

 Earns M.A. from Sacramento State,
 College

 Has graduate show at Crocker Art
 Museum

 Begins teaching at Sacramento City
 College

 Teaches in Honors Department at Sacra-
 mento State College through 1971

 Shows in Kingsley Annual at Crocker Art
 Museum

Dalkey at river, 1968

1970 Takes over Figure Drawing class at Sacramento City College and teaches it nearly every semester up to the present

Solo show of photographs at Art Company

1971 Solo show of paintings and drawings at Art Company

1972 Solo show of drawings at Crocker Art Museum

Quits painting

Teaches in Art Department at Sacramento State College for one year

1973 Resumes painting.

Solo show at Artists Contemporary Gallery, including *The Convalescent Hospital* and the Zoo Series

1974 Solo show of drawings at ACG

1975 *The Convalescent Hospital* included in "Interstices: Northern California Artists" at the San Jose Museum; the show travels to the Cranbrook Academy in Bloomfield Hills, MI.

Included in "50 Years of Crocker-Kingsley" at Crocker Art Museum

1976 Solo show of self-portraits at Open Ring Gallery

Dalkey with son Emile, 1971

1977 Solo show of paintings and drawings at ACG

1978 Begins series of pastels which start with the figure and become increasingly abstract

Solo show of pastels at ACG

Serves on Ad Hoc Committee to found the Sacramento Metropolitan Arts Commission and on panel to select the city's first C.E.T.A. artists

Commissioned by the Sacramento Metropolitan Arts Commission to paint portrait of Councilman Robbie Robertson for the Robertson Community Center in North Sacramento

1979 Included in "Valley Landscapes" at R.L. Nelson Gallery, University of California, Davis

1980 Mother dies

Fred continues working on pastels, turning to mythological themes and themes of death

Moves into studio at 920¹/² J St.

Solo shows of portraits at Sacramento City College and drawings of the Sacramento Youth Symphony at Weinstock's

1981 Solo show of pastels at ACG

1983 Solo show of pastels, many purely abstract, at ACG. *Convalescent Hospital* and other work included in "25 Years of ACG" at Crocker Art Museum

1985 Solo show of landscape drawings at ACG

Helps found the Fred Uhl Ball Memorial Artists in Crisis Fund and serves on its advisory board until the present

1986 Obtains small etching press and does series of monoprints focusing on the female figure, shown at ACG

Shows figure drawings at Sacramento City College

Takes up the violin

1987 Figure drawings included in group show at Charles Campbell Gallery, San Francisco

1988 Included in shows at Charles Campbell Gallery in San Francisco and ARC Gallery in Chicago

Included in "The Thinking Hand: 15th to 20th Century Drawings from the Crocker Collection" at Crocker Art Museum

1989 Receives commission to paint ten landscapes of parks and waterways in Sacramento for the Hyatt Regency, Sacramento

Dalkey teaching at Sacramento City College (with Kathryn Ball), 1975

Dalkey at his exhibition at the American Academy of Arts and Letters, 1992

Dalkey and Wayne Thiebaud at Luiz Cruz Azaceta exhibition at Alan Frumkin
Gallery in New York, 1992

1990 Solo show of Sacramento landscapes at ACG, focusing on Delta sloughs and urban landscapes, especially the light rail lines at 34th and R St.

Visits New York with Wayne and Betty Jean Thiebaud

Begins showing at Campbell-Thiebaud Gallery in San Francisco

1991 Begins weekly sessions painting and drawing the figure with Wayne Thiebaud first at a Sacramento City College classroom and later at Fred's studio on J Street. Sessions continue for approximately five years

Collaborates with Victoria on prints and poems for "In Lak Esh," an exhibition of works by Sacramento artists and poets sponsored by the Sacramento Metropolitan Arts Commission

1992 Makes two trips to New York

Receives Academy-Institute Award from American Academy and Institute of Arts and Letters in New York

Has exhibition at the Academy and solo show of figure paintings at Campbell-Thiebaud Gallery

Included in show of recent acquisitions at the R.L. Nelson Gallery at the University of California, Davis

1993 Solo show of landscape paintings at ACG

Paints in Yosemite with Wolf Kahn

1994 Solo show of figure paintings at Campbell-Thiebaud Gallery

Included in show of Sacramento landscape painters at Thomas Babeor Gallery in La Jolla and in "Persistence of the Human Image" at Fresno City College

1995 Solo show of figure drawings at Thomas Babeor Gallery in La Jolla

1996 Brother Franklin dies. Begins large light rail painting in his memory

Participates in group show at Mongerson-Wunderlich Gallery, Chicago

1997 Invited to make etchings with Enrique Chagoya, June Felter, and Nathan Oliveira in Figure Studio project at Crown Point Press

At the Empire State Building in New York, 1992

Solo show of paintings and drawings at Campbell-Thiebaud Gallery with catalogue of drawings and essay by Richard Wollheim

Included in "The Morgan Flagg Collection" at M.H. de Young Museum in San Francisco; "CSUS/50: CSUS Alumni" at Crocker Art Museum; and "The Quality of Light" in Cornwall, England, sponsored by the Tate Gallery Extension

1998 Solo show of urban landscapes at ACG

With Wayne Thiebaud and Michael Osborne does illustrations for Victoria's book, "29 Poems"

1999 Suffers severe heart attack in June. Hospitalized for 11 days and then undertakes cardiac rehabilitation program

Father dies in December

Included in "Picturing California's Other Landscape: The Great Central Valley" at Haggin Museum, Stockton, CA

2001 Included in "Chestnut Street Stomp" at the Weigand Gallery, College of Notre Dame, Belmont, CA

2002 Retrospective Exhibition at Crocker Art Museum

Included in traveling exhibition, "Perceptual Experience: Contemporary American Figure Drawing," initiated by Frye Museum, Seattle, WA

Dalkey with tin violin, 1948

Playing the violin, 1990

In his J St. studio, 1993

PUBLIC AND CORPORATE COLLECTIONS

Achenbach Foundation for the Graphic Arts,
California Palace of the Legion of Honor,
San Francisco, CA

California State University, Sacramento

City of Sacramento

Crocker Art Museum, Sacramento, CA

The National Gallery of Art, Washington, D.C.
(Crown Point Archives)

R.L. Nelson Gallery and Fine Arts Collection,
University of California, Davis, CA

Sacramento City College

American Justice Institute, Sacramento

California State Fair, Sacramento

Crocker Bank, Sacramento

El Dorado Hills Development Co.,
El Dorado Hills, CA

Huntington Hotel, San Francisco

Hyatt Regency Sacramento

Kronick, Moskowitz, Tiedemann and Girard,
Sacramento

Lytton Industries, Los Angeles, CA

Parker Development, Sacramento, CA

Scottish Rite Temple, Sacramento

Sutter Hospital, Sacramento

The Sutter Club, Sacramento

University of California, Davis, Medical Center

Weinstock's, Sacramento

CHECKLIST

1. *Emile*, 1971
 sanguine Conté on paper
 5 1/4" x 4 7/8"
 Collection of Fred and Victoria Dalkey
 (Page 54)

2. *Karen Onstad by a Window*, 1972
 oil on masonite
 16" x 10"
 Collection of Karen Onstad-Corriveau
 (Page 55)

3. *Monkey*, 1972
 silver point embossing with sanguine
 and gray Conté
 7 3/8" x 5 1/2"
 Collection of Kendall and
 Michaele LeCompte
 (Page 53)

4. *Let's Talk*, 1972
 mixed media on paper
 7 1/2" x 11"
 Lent by the artist
 (Page 21)

5. *Timber Wolf*, 1973
 oil with mixed media on linen
 32" x 27"
 Lent by the artist
 (Page 59)

6. *Convalescent Hospital Studies*, 1973
 oil on panel (15 oil sketches)
 each panel 8" x 10"
 Collection of Marilyn and Phil
 Isenberg
 (Pages 22, 23, 56)

7. *Convalescent Hospital*, 1973
 oil with mixed media
 66" x 87 7/8"
 Collection of Crocker Art Museum
 (Gift of the artist in memory of
 Hans Hohlwein)
 (Page 57)

8. *Barbara McKee*, 1973
 oil on linen
 20" x 20"
 Collection of Herbert Harris Danis and
 Rose Vern Danis

9. *Karen Mast*, 1976-78
 oil on linen
 17" x 14"
 Collection of David and Karen Mast
 (Page 19)

10. *Human Resources Development*, 1978
 pastel with mixed media
 24" x 18"
 Collection of Clyde Blackmon and
 Karen Cornell

11. *Faust's Study*, 1978
 pastel with mixed media
 23 1/2" x 15 1/2"
 Collection of Ada Brotman
 (Page 60)

12. *Self-Portrait without Shirt*, 1980
 oil on linen
 30" x 20"
 Collection of Fred and Victoria Dalkey
 (Page 14)

13.	*Victoria*, 1980
oil on linen
24" x 20"
Collection of Fred and Victoria Dalkey
(Page 65)

14.	*Persephone in Minnesota*, 1981
pastel with mixed media
27" x 24"
Lent by the artist
(Page 61)

15.	*KA*, 1982
pastel with mixed media on paper
29" x 23 3/4"
Lent by the artist
(Page 62)

16.	*Eve,*1983
pastel with mixed media
27" x 23 1/2"
Collection of Barbara Bumgarner
and Frank Teribile

17.	*Mumbling*, 1983
pastel with mixed media on paper
26 3/4" x 23 1/2"
Lent by the artist
(Page 43)

18.	*Avignon*, 1983
pastel with mixed media on paper
27" x 23 1/2"
Collection of Fred and Victoria Dalkey
(Page 63)

19.	*Passion*, 1983
pastel with mixed media
33 1/2" x 23 3/4"
Collection of Fred and Victoria Dalkey
(Page 64)

20.	*Barbara Zook*, 1984
oil on linen
8" x 11 1/2"
Collection of Barbara Zook Caine

21.	*Victoria*, n.d. (c. 1985)
sanguine Conté on paper
9 1/2" x 8 1/8"
Collection of Fred and Victoria Dalkey
(Page 66)

22.	*Life Class*, n.d. (c. 1985)
sanguine Conté on paper
13" x 9 1/2"
Collection of Fred and Victoria Dalkey
(Page 91)

23.	*Emile*, 1987
pastel on paper
18" x 15"
Collection of Fred and Victoria Dalkey
(Page 68)

24.	*Emile*, c. 1990
oil on linen
30" x 24"
Collection of Fred and Victoria Dalkey
(Page 69)

25.	*Driving Down 4th Ave.*, 1988
oil on linen
24" x 24"
Collection of Anne and Malcolm
McHenry
(Page 70)

26.	*Land Park Pond*, 1988
oil on linen
36" x 48"
Collection of Susan and Thomas
Willoughby
(Page 29)

27.	*34th and R, Looking East*, 1990
oil on board
11" x 14"
Collection of Betty Jean Thiebaud
(Page 74)

42. *Victoria*, 1992
 oil on linen
 24" x 18"
 Collection of Fred and Victoria Dalkey
 (Page 67)

43. *Self-Portrait*, 1992
 oil on linen
 17" x 17"
 Collection of Andrea and Greg Trautman

44. *Self-Portrait*, 1993
 charcoal and white Conté on paper
 19 1/2" x 15 3/4"
 Collection of Mr. and Mrs. James V.
 de la Vergne
 (Page 8)

45. *Tabitha*, 1993
 oil on linen
 50" x 30"
 Collection of Mr. and Mrs. Harry
 Parker, III
 (Page 84)

46. *Self-Portrait*, 1994
 Russian sanguine on paper
 9" x 8 1/4"
 Collection of William Mandelstam

47. *Tabitha Covering Her Face*, 1994
 oil on linen
 44" x 28"
 Lent by the artist
 (Page 35)

48. *Tabitha with Red Hand*, 1994
 oil on linen
 48" x 32"
 Lent by the artist
 (Page 47)

49. *Stacey #I*, 1994
 oil on linen
 48" x 32"
 Collection of Carl and Ann Nielsen
 (Page 78)

50. *Frieze*, 1994
 oil on linen (4 panels)
 60 1/4" x 124"
 Collection of Steven and Nancy Schwab
 (Pages 37, 79)

51. *Julie Rising*, 1994
 sanguine Conté on paper
 9 1/4" x 8 3/4"
 Collection of Russ Solomon and
 Elizabeth Galindo
 (Page 45, 92)

52. *Miss Rose (after Delacroix c. 1821)* 1994
 sanguine Conté on paper
 9 5/8" x 7 1/2"
 Collection of Wendy Turner
 (Page 93)

53. *Woman in Profile*, 1994
 sanguine Conté on paper
 10 5/8" x 8 3/4"
 Collection of Anne and Malcolm
 McHenry
 (Page 94)

54. *Skull on a Table*, 1994-5
 sanguine Conté on paper
 8 1/8" x 10 3/4"
 Collection of Larry Evans Fine Art
 (Page 95)

55. *Stacey with Weeping Green (Kore)*, 1995
 oil on linen
 24" x 24"
 Collection of Fred and Victoria Dalkey
 (Page 83)

56. *Stacey with a Morandi Still Life*, 1994
 sanguine Conté on paper
 12 1/4" x 10 1/2"
 Collection of Morgan Flagg
 (Page 26)

72. *Red Sky at Morning Sketch*, 1996
 charcoal and oil wash on linen
 26" x 16"
 Lent by the artist
 (Page 86)

73. *Red Sky at Morning*, 1998
 oil on linen
 68" x 44"
 Collection of Gregory and
 Andrea Trautman
 (Page 87)

74. *Kim Modeling in the Classroom*, 1998
 sanguine Conté on paper
 9 7/8" x 8 7/8"
 Lent by the artist
 (Page 99)

75. *Jian Wang*, 2000
 sanguine Conté on paper
 8 7/8" x 7 3/8"
 Lent by the artist
 (Page 98)

76. *Self-Portrait with Hands on Hips*, 2001
 oil on linen
 28" x 32"
 Collection of Fred and Victoria Dalkey
 (Cover, title page)

77. *Ginger Jar, Soy Sauce Bottle, and
 Ball of String*, 2001
 sanguine Conté on paper
 9" x 10 3/8"
 Lent by the artist
 (Page 100)

78. *Ginger Jar, Soy Sauce Bottle,
 and Baseball*, 2001
 sanguine Conté on paper
 9 3/4" x 8 7/8"
 Lent by the artist
 (Page 101)

SELECTED BIBLIOGRAPHY

Baker, Kenneth. "Frederic Dalkey," in *Art News*,
 September, 1997, p.139.
____. "Dalkey Drawings," in *San Francisco Chronicle*,
 May 6, 1997, p.E4.
Ball, Fred. "Art Has Passion, Classics Touch," in *The
 Sacramento Bee*, May 22, 1978.
____. "Dalkey on Dalkey," in Artweek, February 28,
 1976.
____. "Drawings of Wit and Nuance," in *Artweek*,
 July, 1974.
____. "Fred Dalkey," Artweek, September, 1973.
Belt, Debra. "Artists Contemporary Gallery Shows
 the Cream of the Crop," in *The Sacramento
 Bee*, December 29, 1994, Interiors, p.5.
Bennett, David. "Dalkey Draws What He Feels," in
 Express, November 20, 1986.
Blue, Jane. "Art Checks In," in *Horizon: Valley Arts*,
 June, 1988.
Brown, Kathan. *Why Draw a Live Model: Etchings
 and Drypoints by Enrique Chagoya, Fred
 Dalkey, June Felter, Nathan Oliveira.* Crown
 Point Press, San Francisco, 1997.
Bruner, Louise. "Cranbrook Exhibitions Receive
 Bad Marks," in *The Blade*, Toledo, Ohio,
 March 2, 1975, p.4.
Clifton, Leigh Ann. "American Academy Awards,"
 in *Artweek*, August 6, 1992, p.14.
Couzens, Julia. "Davis Galleries Feature Sacramento
 Valley Landscapes," in *West Art*, May 25,
 1979.
Glackin, William. "Dalkey's Art: Compelling,
 Symbolic, Powerful," in *The Sacramento Bee*,
 November 30, 1983.
Gordon, Allan. "Fred Dalkey at ACG," in *Artweek*,
 January, 1999, p.21
____. "Flatlanders: Sacramento Valley School," in
 Artweek, February 3, 1994.
Grizzell, Pat. "Traditions," in *Suttertown News*,
 November 20-27, 1981, p.5.

Hale, David. "Variety of Figurative Art Worth
 Another Look," in *The Fresno Bee*, 1994.
Halsey, Jan. "Artists Depict Sacramento Valley," in
 Woodland-Davis Press Democrat, 1979.
Howard, Julie. "Corporate Boosters Boost
 Sacramento's Art, Museum Collections," in
 The Sacramento Bee, April 17, 1993, p.C7.
Johnson, Charles. "Mysterious Shows and
 Otherwise," in *The Sacramento Bee*,
 February 20, 1977, Scene, p.3.
____. "Public Murals, Private Portraits," in
 The Sacramento Bee, February 15, 1976, p.3
____. "Sly Bits of Artful Humor," in
 The Sacramento Bee, November 4, 1973.
Johnson, Holly. "Celebrating a Tradition in
 Contemporary Art," in *The Sacramento Bee*,
 April 18, 1993, Encore, p.6.
Julian, Kimi. Review, in *Sacramento News and
 Review*, November 12, 1998, p.29.
Kay, Alfred. "Genius Flickers in Unfinished
 Sketches," in *The Sacramento Bee*,
 December 23, 1988.
____. "Tiny Prints Carry a Big Impact," in
 The Sacramento Bee, November 23, 1986.
____. "How Green Is the Grass?" in *The Sacramento
 Bee*, October 27, 1985
____. "Dalkey, Gavin in Capital, Rodriguez in
 Oakland," in *The Sacramento Bee*,
 February 16, 1980, p.A13.
____. Review, in *The Sacramento Bee*, May 22, 1978.
McColm, Del. "Fine Drawings in Pence Show
 of Nudes," in *Davis Enterprise*, January 23,
 1981.
Melton, Peter. "Artists Do the Impossible," in
 Express, September 23, 1982, p.5.
Pincus, Robert L. "Trendiness Isn't in Nature of
 'Sacramento Valley School,'" in *San Diego
 Union*, August. 1994.

Robinson, Walter and Anastasia Wilkes.
"Art World," in *Art in America*, July 1992,
p.126.

Sacharow, Anya. "Spectrum," in *ARTnews*,
Volume 91, no. 6, Summer 1992, p.27.

Schlesinger, Ellen. "Painting the Town," in *The
Sacramento Bee*, July 28, 1985, p.50, 52.

_____. Review, *The Sacramento Bee*, February 3,
1984.

Seville, Johnathan. "Are Oil Tanks Filled with
Oil or with Beauty?" *San Diego Reader*,
August 4, 1994.

Simon, Richard. Interview, *Sacramento Union*,
January 12, 1985.

_____. Review, *Sacramento Union*, January 12, 1984.

_____. "Dalkey: An Imagination Fired by Ancient
Gods," in *Sacramento Union*, November 8,
1981.

_____. "Brilliance from Modest Beginnings," in
Sacramento Union, February 9, 1980,
p.C12.

Snow, Shauna. "Art Notes," in *Los Angeles Times*,
May 10, 1992, 84

Staff. "Fred Dalkey Wins $7,500 Award," in
The Sacramento Bee, May 24, 1992, Scene.

Staff. "Sacramento City College Art Instructor
Receives National Award," in
Community College Week, May 11, 1992,
p.9.

Staff. "An Artist Looks at Young Musicians at Work,"
The Sacramento Bee, January 26, 1980, p. H6.

Sylva, Bob. "Flicker of Recognition," in
The Sacramento Bee, 17 November 1993,
Scene, p.1.

Vaughn, Rhiannon. "Art Instructor Sets Students
Minds' Free," in *Express*, August 26, 1999,
p.5.

Weinberg, Viola. "Artists and their Studios," in
*Inside Ar*t, July 1980, p.5.

Willliamson, Marcia. "A Capital Collection of
Public Art," in *Sunset Magazine*, March
1993, p.21.

Wolheim, Richard. "The Drawings of Fredric
Dalkey", in *Fredric Dalkey. Life Drawings*.
Exhibition catalogue, Campbell-Thiebaud
Gallery, San Francisco, April 22, 1997.

PHOTO CREDITS

Stuart Allen:
Pages 17, 22, 23, 29, 41, 43, 47, 55, 56, 57, 59, 60, 61, 62, 63, 64, 70, 71, 72, 74, 76, 85

Chris Daubert:
Page 25

Ferrari Color:
Pages 8, 14, 19, 21, 31, 35, 39, 49, 53, 54, 65, 66, 67, 68, 69, 75, 77, 81, 82, 83, 86, 91, 94, 96, 97, 98, 99, 100, 101, 107, 109 and the cover

Kurt Fishback:
Page 11

Lucas Hepler:
Page 73, 87 and the back cover

Leilani Hu:
Page 125

Roy Porello:
Pages 9, 33

Ira Schrank:
Pages 45, 51, 89, 92, 93, 95, 103, 113

Tom Van Eynde
Pages 37, 79

CROCKER ART MUSEUM

CROCKER ART MUSEUM CO-TRUSTEES

The Honorable Heather Fargo
Mayor, City of Sacramento

CROCKER ART MUSEUM ASSOCIATION
Board of Directors

Roger Berry, President
Estelle Saltzman, Vice President
Linda Merksamer, Secretary
Marc Sussman, Treasurer
Marcy Friedman, Past President

Russell Austin
Max Besler
Nancy Brodovsky
Julia Couzens
Michael Dunlavey
Doug Elmets
Daphne Gawthrop
John Hamlyn
Jan Hardie
Brice Harris
Michael Heller, Jr.
Maria Kaufman
Thomas Markin
Tom Minder
Pilar Montoya
Dan Ramos
Susan Ritchie
Randall M. Schaber
Russ Solomon
Gunter Stannius
Kyriakos Tsakopoulos
Loretta Walker
Tom Weborg
Sandra Yee

CROCKER ART MUSEUM FOUNDATION
Board of Directors

Mike Genovese, President
Donald Poole, Vice President
Pramila Kriplani, Secretary
Margaret Kane, Treasurer
Susan Willoughby, Past President

Edith Brandenburger
Daniel Crosbie
David M. Delehant
Pam Hurt-Hobday
Gloria Jones
Oleta Lambert
Ken Larson
Kay Lehr
Sharon Margetts
Trudy Nearn
Shirley Plant
Ronald G. Pomares
Charles Roberts
Peter Scheid
Bob Slobe
Sofia Tsakopoulos